Noh-Noh Girlz

Reimagining Japantown

A novel by

Sheridan Tatsuno

DREAMSCAPE GLOBAL
San Francisco, California

Also on Amazon by

SHERIDAN TATSUNO

Non-Fiction
The Technopolis Strategy
Created in Japan
In the Valley of Digital Dreams
The Gaiapolis Strategy

Poetry
San Francisco Cantos
Land of a Thousand Dreams
Chaos
Ghost Cities, Floating Cities

Novels

Virtually San Francisco Series
Virtually San Francisco (Tenderloin)
Uniquely San Francisco (SOMA)
Soulfully San Francisco (Fillmore/Japantown)
Divinely San Francisco (East Bay)
Zenfully San Francisco (Japantown)
Virally San Francisco (UCSF Mission Bay)
Fashionably San Francisco (Chinatown)
Beatfully San Francisco (North Beach)
Haightfully San Francisco (Haight Ashbury)
Cosmically San Francisco (Virtual Mars)

Gaiapolis: Rim of Chaos

Japantown Series
Kimono Minds
American Kabuki
Solar Jive
Bunraku Knights
Noh-Noh Girlz

Noh-Noh Girlz – a primer

Two "Catch 22" loyalty questions were given to Japanese Americans imprisoned in the World War II concentration camps by the Army and War Relocation Authority (WRA) to separate the "loyal" from the "disloyal":

Question 27: For men: Are you willing to serve in the Armed Forces of the United States on combat duty wherever ordered? For women and Issei (first-generation): If the opportunity presents itself and you are found qualified, would you be willing to volunteer for the Army Nurse Corps of the WAC? Question 28: Will you swear unqualified allegiance to the United States of America and faithfully defend the United States from any or all attack by foreign or domestic forces, and *forswear any form of allegiance or obedience to the Japanese emperor* or to any other foreign government, power or organization?

Answering "no-no" branded the person, citizen or "alien" (Issei immigrants who were denied citizenship until 1952) as "disloyal", leading to their transfer to the Tule Lake prison camp in northern California and deportation to Japan. **"No-No"** prisoners protested their loss of freedoms and constitutional rights, which still splits the Japanese American community.

Noh, derived from *nō*, meaning "talent" or "skill"— is a major Japanese dance-drama art form that has been performed in masks and costumes since the 14th century to tell stories symbolically where little "happens." Performances feature five categories: God, Warrior, Woman, Deranged and Demon. Noh masks reflect gender, age and social ranking. For Japanese Americans, stoic masks maintain one's face and honor despite strong anti-Asian hostility and family pressures.

"Girlz": an attractive young woman with sex appeal and an engaging personality, such as Clara Bow in "It" (1927), a term originating among British upper classes in the early 1900s. Today it means: 1) females spending time with diverse friends and all of their fun fashions, friends and accessories, 2) strong females with style, 3) the message that girls should be proud of themselves and stay true to their dreams.

Enjoy the trials and tribulations of our "Noh Noh Girlz" warriors!

The characters and personal stories in this novel are purely fictional, but based on real historic events.
Any resemblance to real people is purely coincidental.

Copyright © July 2024 Sheridan Tatsuno
Dreamscape Global
San Francisco, California
All rights reserved

ISBN: 9798332487323

We build our futures
Upon the ghosts of the past

Part 1

Recreating the Past

1

VICTORY! NOW WHAT?

"Girlz," announces my mother, grinning like our purring Persian cat. "We did it! We Moriokas rock! We beat Mayor Tiffany fair and square. The City is not evicting us!"

My mother gloats over our surprising victory. Mayor Tiffany-Wong Gonzalez is running for re-election in a tight race so she had little choice but to back the City's goal of revitalizing communities by making way for a massive luxury housing and retail complex, even at the expense of evicting our landmark Kimono Minds shop, but mom outwitted her by showcasing her "Seven Samurai" girlfriends who wore their finest kimonos made of textiles reflecting our multicultural diversity – African, Indian, Mexican, Italian, Russian and Malaysian – to protest our eviction in front of city hall, which was broadcast worldwide. We are famous! Billions of viewers saw mom's gorgeous kimonos so protesters are demanding the City not evict us artists. This is truly one of the most amazing days in our lives. Imagine that, a small Kyoto kimono designer in Japantown facing off with one of the smartest, most powerful mayors in the United States – a former Mission gamer, Navy "Top Gun" pilot in Iraq and a Stanford computer science grad – and winning without a waging a grinding political battle.

Mayor Tiffany, our nickname for her since she is a close family friend who grew up near Japantown before moving to the Mission, is a tough "Iron Lady" who brooks no dissension from anyone, including rich, powerful white men. She stands up for women, people of color and the poor since she grew up in the 'hood. She is a walking powerhouse and a political oddball -- an ultra-blue politico who wears her military service with pride. Nobody messes with her, especially attorneys and rivals. She chews them up for breakfast, lunch and dinner, which is why our victory is so sweet. In

a gracious move to save face and win the election, she conceded defeat to our mother before the cameras, bowing deeply to her "Seven Samurai" girlfriends in kimonos, apologizing profusely and promising the City will never evict Japanese Americans again from Japantown, as the federal government did with the World War II concentration camps and the SF Redevelopment Agency's "Second Relocation" after the war when it kicked out Japanese and Black families and shops, shrinking Japantown from forty blocks to four blocks today.

For us shopkeepers, it is unbelievable that the City has the audacity to evict us again. Is it trying to gut Japantown? No way! We won't go! It is our homeland, just as the Bay Area is the original homeland of the Ramaytusch Ohlone peoples. We were born here, grew up here and will die here. We will never allow anyone to force us from our land again.

Mom is cheering. Kimono Minds is now one of the most famous kimono brands in the world, thanks to poor Mayor Tiffany who is suffering a rain of laughter because of her monumental misjudgment and inability to evict a small shop to make room for a massive urban redevelopment project reshaping Japantown and the Fillmore, one of the last bastions of developable land in the heart of the City. Mayor Tiffany is now mocked as another mayor favoring big developers over local artists – a huge no-no among old-time San Franciscans who take pride in our multicultural peoples and arts. We are the "UN of Cultural Arts" and the Asian American capital of the United States. No American city comes close to our kumbaya spirit. Japantown and the Fillmore are keys to our future. They sit at the crossroads of the City, two communities "joined at the hip" and nearly eliminated by the 1950s urban renewal programs which James Baldwin fittingly called "Black removal." Being minority and poor, we are always in the crosshairs of big developers. We shopkeepers are the few surviving dreamers. We hang tight and try to make the City a kinder and better place for everyone by defending our valuable heritage and little turf of land. We are the last artists standing.

Mom is feisty and taught us to stand up for ourselves. Her don't-mess-with-me toughness rubbed off on my sisters -- Mariko, Emiko, Yumiko – and me. We inherited her entrepreneurial genes; we are launching our own ventures – fashion for my sisters and robotics for me – and adopted her take-no-prisoners attitude. We are

stubborn folks with *gaman* (perseverance), her favorite word. We may be poor and split over our career goals and fashion styles, but we agree on one thing: We will never leave Japantown. This is our Tara.

But our dreams and hopes are totally out of synch with today's harsh realities. The City is way too expensive for most families and shops, with rents eating up half of our incomes, and is getting worse with billionaires and corporations taking over elections and buying up land and buildings to reshape the City into their own image – a playground for the uber-rich – while running over us little folks. We see highrises go up around us and supermarkets shutting down without advanced notice. The City is cutting deals in secret with major corporations to redesign Japantown and the Fillmore, just like the 1950s when it approved the massive Japan Center, which displaced 50 family businesses, 1,500 people and precious Victorians. This time billions of dollars in construction jobs, retail sales, property values and tax revenues are at stake. Mayor Tiffany has the dubious honor of presiding over this corporate invasion coming out of Covid-19 lockdowns. For her, it is a personal dilemma. She grew up poor like us, but because of her Stanford education and global fame, she is caught in the jaws of massive corporations and tech billionaires who increasingly call the shots in the City. Like us poor Japantown and Fillmore folks, she is becoming a puppet to corporate interests, just as my father, a Bunraku puppeteer, feared. What irony! Our proud "Top Gun" Mayor Tiffany being played as the latest political puppet. I should perform a Bunraku play about her existential dilemma as our "Lady Hamlet."

So here we sit in our little shop, gloating, but clinging to our lifeboat since we know it may be a pyrrhic victory. Bulldozers are coming fast since corporations smell huge profits. They can easily out-finance and out-lobby us with land purchases, huge construction contracts, campaign donations, TV and radio ads, and election posters. We are powerless puppets in their way. History repeats itself. Do we have a chance to reimagine and reshape Japantown while battling these giant outsiders? I'm skeptical. Mom disagrees, insisting that we stand firm and never give up. She constantly reminds us: "In Kyoto, we build the future onto the past, not demolish it like Tokyo." That may be true in Kyoto, but this is Cash Francisco. Everything comes down to money; it is always one gold rush after another.

Japantown is a tempting doormat for big developers; we are just getting in their way, but mom refuses to compromise. She says we must fight with our Daruma spirit (seven times down, eight times back up). No matter how small, weak and poor we may be, we will never, ever give up and bend to the powerful. Like our heros, the famed 442nd/100th Infantry Battalion who routed Nazis in World War II, she says we must hunker down and embrace their "Go for Broke" drive and determination. We must never concede; we must win. The alternative is oblivion. I wish it were easier but that is our fate.

"Brad," says Yumi, my youngest sister. "You look dazed. What's on your mind?"

"I'm worried about the future," I reply.

"Me too. What's next, right?"

"Yeah, I'm freaking out. Mom wants to rebuild Kimono Minds, but we have almost no money and few customers. Realtors are throwing money at her to buy us out. We can't survive unless something drastically changes."

"Like what?"

"Good question. All our options look dismal."

"You can't give up. We all need you since you're running the show, thanks to dad's coaching. You need to step up and figure out something."

"I'm not a finance guy. I'm just a high school junior who wants to be a robot designer, not a kimono shopkeeper and Bunraku puppeteer forever. Like you, I have dreams too. I want to work with top robot designers on cool stuff, not spend the rest of my life in this cramped studio."

"Another penniless dreamer…"

"Aren't we all? What about your AI avatars, Mariko's goth fashions, and Emi's cosplay fashions? Where will we get the money to finance our beautiful dreams? Most retailers and fashion designers fail. How do we build our ventures without sinking our shop?"

"Help mom until we figure out our jail break. You're essential. Without you, we'll lose everything. We'll be evicted and have to leave town."

"I hate the term "essential worker." It reminds me of the poor hospital and slaughterhouse workers who died during Covid-19. I don't want to sacrifice my dreams selling kimonos and fighting

evictions. I want to build a cool robot company."

"Gaman (hang in there), dreamer. We need you."

I smack my head. Why were we born to a crazy kimono designer from Kyoto who lives in the glorious Heian past? Why can't mom join the 21st century? Why does she pretend we're living in the land of "Shogun"? Kimonos are so old school. If I have to be her manager forever, I'll go nuts. Mom and dad deserved each other's madness – gaudy kimonos and Bunraku puppets. It was their choice, but why burden us kids with their obsessions and dreams? Why me?

Our parents were crazy artists who defied their parents. Mom left her family's kimono business dating back centuries. Dad became a Bunraku master who dressed me up in samurai outfits to play the glorious "Chushingura" leader who commits ritual suicide (*seppuku*) in his play. Now mom wants me to commit professional seppuku and sacrifice my robotics career. Am I cursed or what?

"Why do we have to live in Japan's fabled past? I'm sick of it. I want to live in the future."

"Chill out, Brad," says Yumi. "Mom will give you some slack. You just have to help her through this tough patch."

"Easy for you to say. You're at Cal so you can avoid her crazy antics. I'm the one stuck in the backroom fixing stuff and this tough patch may last a long time."

Yumi pats me on the back.

"Life will get better," she says. "I know it. You're the little one so you're her baby. Since dad died, she needs you more than ever. She's hurting. At night, I hear her crying so give her a break and comfort her. It will do you both some good. Gambatte! (hang in there). That's the best thing you can do to honor her and dad. They had strict parents but still pursued their dreams. We can too. It runs in our family. We're like bamboo. We bend but never break."

Yumi and I gaze at the Japanese, American and California flags flapping under the towering pagoda in the Peace Plaza. How symbolic. That's our family – proudly smiling in public, but privately miserable with our frustrated dreams and lousy finances. We're like the Cherry Blossom Festival princesses; we must smile for our fans, customers and the media since it's always showtime. Dad was blunter, saying: "A samurai never cries." Despite our troubles, we Moriokas must carry ourselves with dignity and pride since we

represent Japantown to the world. Bowing deeply, smiling faces, kimonos and Bunraku plays -- the heart and soul of our ancient culture. As a family, we rock but, thanks to mom, the pressures are driving me insane. I just want to call it quits but dare not since our family face, business and honor are at stake. That totally sucks!

Enough monku-monku-monku (complaining) for now. Mom needs help for her upcoming kimono fashion show at the Kabuki Hotel, where dignitaries from around the world will celebrate Japantown's recovery. I am slotted to perform a wild Bunraku play about the dark days of the pandemic and our miraculous recovery through laughter, dance, music and general craziness. I'm not sure what to perform. Japantown was totally dead, a spooky ghost town with seniors vanishing from Covid-19, dad dying from overwork, and mom grieving and going ballistic with us. I could show zombies and talking with the dead in the Japanese cemetery in Colma, like the "Nightmare before Christmas." It would be realistic -- a Barbary Japantown of the Dead -- but it might freak out people so mom would probably kill me. How can I tell a fascinating story like "Chushingura" without the horror? I need something less traumatic and more joyous, but what? Something spectacular and magical that will grab people. I am the Japantown storyteller so it's up to me. I'm the Bunraku puppeteer and mom's little puppet.

2

MUTINY

"Mariko, try wearing this kimono that I designed for the fashion show," says mom.

"No way," replies Mariko. "I'm not wearing some stupid kimono that looks like a waterfall."

"Please, just this once. Everyone expects the oldest daughter to grace our performance with her refinement."

"Screw refinement! I'm into Goth fashion. You know that. Why do you always insist that I wear frilly kimonos? Are you trying to harness me like a clothes horse?"

"You should be grateful to open the show with this gorgeous kimono. It's one of a kind, my first waterfall design. It's special."

"Mom, can Emi or Yumi wear it? I'll just watch. I'll do anything except look like a pathetic waterfall. I'll sweep the floors, serve tea and clean up -- anything."

Mom hands Mari her new waterfall kimono, but Mari refuses. Mom looks sad and exasperated.

"What's the matter with you girlz? You want to be fashion designers. This is the perfect opportunity to be gorgeous and famous in front of fashion journalists from Tokyo, Paris, Beijing and Milan. Most models would die to wear my kimonos."

"Let them, they're just models," says Mari. "We're designers. I prefer my own line of Goth designs, something that I believe in and that sells."

Mom sits down on her workbench and shakes her head, faking a deep moan.

"I came all this way to America, built Kimono Minds into one of the top kimono shops on the West Coast and you girls make fun of me. How embarrassing! We don't do that in Kyoto."

"Mom, we're not in Kyoto. This is San Francisco. We dress any way we want."

"But it's tradition. We Moriokas are famous in Kyoto so we need to maintain our brand and prestige."

"Mom, how many times do I have to tell you? I'm not into kimonos, just hip Goth fashions, cool stuff that my friends can wear anywhere. Kimonos are so – stuffy."

My mom turns to Emi and Yumi who watch the argument with fear in their eyes.

"Emi," says mom. "You're next in line so perhaps you can wear my new design."

"Can Yumi do it? I'm busy preparing my latest cosplay line with my designer friends."

"Just once. You'll get lots of media coverage."

"Sorry, I don't want to be pegged as a kimono traditionalist. I need to be avant-garde with my J-Pop fans. They would totally freak out if they saw me in a kimono. That is so last century. Yumi can show your kimonos with her AI avatars."

"Avatars? I don't want a fake online show. I only host real fashion shows with real kimonos, real models and real people. Stop living in fantasylands with fake models. We're Kimono Minds. We live in the real world with real kimonos."

My sisters sigh, shaking their heads. Ever since dad died, mom has totally lost it and caused mutiny on our little ship. My sisters refuse to have anything to do with her kimonos since it distracts them from their own fashion work. Our home has turned into a regular sumo match for fashion designers, with my mom and sisters wrestling and throwing each other around like shifty sumos. As the youngest kid, I just watch with amazement at their swift moves. Women can be tough and cagey like guys. They know how to strike and parry like the best sumo wrestlers. I am not a sumo fan but it's the closest thing I can think of that fits our family.

"Guys," I say. "Why don't we pick straws? The one who picks the shortest straw gets to show mom's waterfall kimono."

"No way!" says Mari. "You can count me out."

"Me too," says Emi. "I need to prepare for my cosplay show."

"Cal has final exams next week so I'm busy," says Yumi. "That leaves you, Brad. You can cross-dress and wear mom's kimono. I thought you were into transgender rights."

My sisters burst out laughing, which irritates mom to no end.

Mari grabs the kimono and drapes it over me. I look like a freaking waterfall. More laughter. I have to admit; I do look funny. Maybe I should wear the Noh mask of a beautiful woman. Nobody would know. But mom is not pleased and grabs the kimono from me.

"If none of you will wear it, I'll find a woman who does," says mom. "You'll regret missing this chance to be famous."

My sisters roll their eyes.

"I can see the headlines now," says Mari. "Yosemite Waterfall Comes to SF. In full John Muir blues, greens and grey."

We all laugh.

"That's not funny," says mom. "I put my heart into this kimono."

"We know you did," says Emi, holding her stomach, bent over laughing. "But we're all busy with our own fashion lines. I hope you understand that it's not about your design. It's about our future."

"What about my future?" asks mom. "Our future? Without Kimono Minds, we cannot pay our bills and we'll end up on the streets of San Francisco."

Emi gives mom a big hug.

"Don't worry, mom," says Emi. "We'll never let that happen. Brad will figure something out."

Mom turns to me.

"Brad, I'm so happy I can rely on you."

"What about the girls? Why just me?"

"Cuz we're all busy," says Mari. "You have plenty of time since you're on summer break."

"That's unfair. You guys need to pitch in."

"Tell us when you need help," says Emi. "We'll pitch in."

"Thanks," I say, giving up.

"Brad, you're such a wonderful son," says mom, hugging me. "Dad trained you right."

I sigh. That's my family for you -- totally crazy designers, totally self-centered and totally poor.

Mari, Emi and Yumi gather for a big family hug. We may not agree on anything, but at least we hang together through thick and thin. As dad always said: A family that fights together, stays together. But I always end up being the referee and cleanup man.

"Girlz," says mom. "You think I'm crazy, but I'm no

crazier than you. We original designers are all crazy. We must be to create the new and the impossible. I just don't want you to run off and abandon me. I need your help. After all, we're family. We crazy designers need to stay together."

"And hang together," says Mari, smirking.

Mom suddenly looks sad, as though we are going to abandon her. Mari gives mom another big hug.

"Sorry, mom. We love you, but we just need to follow our dreams too. We only have one life to live and want to be happy like you and dad were when you disobeyed your parents."

"But we kept our traditions. You are all losing them."

That is the joy and sadness of our family. We design; we argue; we rebel; we make up, again and again. It is in our DNA. Mom and dad left home to pursue their dreams. Dad left SF to become a Bunraku master in Osaka. Mom left Kyoto to pursue her dream here. Now my sisters and I want to pursue our dreams. We are inveterate dreamers.

"I cannot stop you, but don't leave me like I did to my family," says mom. "They never forgave me. We cannot make the same mistake. We need to stay close so we can do awesome things together."

Mom is right, but awesome? She has never used that word before. Is she smoking something? We all smile, knowing in our hearts that we kids are rebels but need each other to avoid getting lost. She is momma duck and we are wild little ducklings following her footsteps to find the next feeding spot.

3

POP-UPS

My sisters have avoided mutiny but they face the intimidating challenge of building their budding ventures while keeping our Kimono Minds shop afloat. Scrounging with tiny budgets, they set up pop-up exhibits in our tiny showroom. Mari gathers her Goth designer friends and creates a dazzling line of Regenerative Goth designs using hemp, cottons, silk, soy, banana peels and new biomaterials. Her hemp fans pack our shop. Emi works with her girlz to create her Emiko line of frilly cosplay outfits, ranging from French maids and Victorian ladies to J-Pop anime animals and Kaguyahime snow princesses. Yumi creates AI avatars in Goth and cosplay outfits for online fashion shows in YumiLand. I build cool samurai robots with flashing armor for my Robot World. Our shop overflows with Goth and cosplay fashions and my robots competing for space with mom's kimonos.

"Girlz!" says mom. "Can you put your pop-ups in the corners so they don't block our kimono displays?"

Our kimonos? My sisters grudgingly move their pop-ups, making our shop look like a vintage store filled with recycled fashions overwhelming mom's waterfall kimono collection.

"I don't think this is working," says mom. "We're losing the essence of Kimono Minds. We look more like a used clothes store than a nice boutique. Can't you reduce your collection sizes?"

"We'll move out," says Mari. "Then we won't get in your way."

"To where? Space is tight and expensive in Japantown."

"A new GOBO cultural center just opened up near the Peace Plaza. We can move there."

"How much will it cost?"

"It's cheap and we're only doing weekend pop-ups."

"Do you have to move? Maybe we can redesign our shop so you all fit in. Cozy family style."

"Mom," says Yumi. "Thanks for the consideration but I don't think it will work. Our styles are too different. We look like a costume store."

"But your designs are costumes."

"Yes, but we have pride in our designs. They're not just for parties and performances, but for everyday wear."

"Everyday? People actually walk around town wearing Goth and cosplay outfits? I would never do that."

"Mom, you're so traditional Kyoto," says Emi. "Think Harajuku. We can have the coolest J-Pop cosplay fashions in the Bay Area."

"We're Kyoto, not Harajuku. That's for kids."

"We're in tune with the times, not selling to old folks who wear kimonos to weddings and fancy parties."

"We're street, not royalty," says Mari. "We need to flow with the times, not resurrect the ancient past."

"But Kimono Minds is who we are – proud descendents of my family's long Kyoto fashion tradition."

"Mom, please," begs Emi. "Do we have to go there again? Mari, Yumi and I are opening our pop-up shops across the street. We won't be far and we can direct kimono fans to you."

"It won't be the same without you. Our shop will be quiet and lonely."

"We'll be nearby, not across town. Please let us try."

Mom looks at Mari, Emi and Yumi with a sad and skeptical look on her face. That's all we need; another showdown between Heian Kyoto and J-Pop Harajuku, two vastly different worlds with two different styles and mindsets. Everyone looks to me for an independent viewpoint. I hold my tongue, knowing my words could further split our fractured family.

There is total silence, with my mother and sisters staring each other down like samurai. Who will speak first? Who will cave?

Finally, after a long silence, my mother exhales.

"OK, you may open your pop-ups across the street."

My sisters cheer.

"But you'll come if I need help?"

"Anytime, mom," says Emi. "We promise to stand by you and Brad whenever you need anything."

Emi gives mom a big hug, joined by Mari and Yumi. At least we avoid another showdown or, even worse, a breakup. Mom smiles, but I can tell she is unhappy. I am her confidante so she tells me everything that she cannot say directly to my stubborn sisters. To be fair, they are both right, but they are stubborn women who refuse to compromise. No wonder Kyoto Minds has survived decades of volatile sales, led by my mom and her strong women designers, but can it survive my volatile sisters?

I'm just play the sumo referee, line judge and Bunraku narrator, but I want a more active role. Maybe I should turn our little family drama into a play. What could I call it? "Fashion Ninjas?" or "Juku Town?" I will do whatever I can to help my mother and sisters, but what about my robot venture? Maybe my sisters' pop-ups will give me ideas. Let's see what happens.

4

FASHION FREEDOM

My sisters are ecstatic over mom's concession. They are free to test their fashions in the new GOBO cultural hub. Like butterflies, they flutter about putting finishing touches on their latest designs. Mari prepares a sleek line of black and white Goth leather jackets, vests and pants for the summer Obon festival; black for westerners and white for traditional Asians who view white as a sign of death. Emi designs a trippy line of psychedelic Summer of Love cosplay gowns and recycled capes that mix 1960s SF vibes with "A Midsummer Night" fantasy dreams. Yumi goes over-the-top with exaggerated anime versions of their fashions. I create robot puppet versions for my Bunraku plays. We are totally in our bliss working on the things we love, not just schlepping mom's kimonos, but mom feels left out and approaches me for help. I nod, agreeing to help, but feel a little too much pressure so I take a walk with Mari to ask for advice without mom around.

"Mom is totally out of her mind," says Mari. "Maybe it's early-stage dementia. She still thinks people will buy $10,000 to $20,000 kimonos for Obon parties and weddings. Maybe rich old ladies in Pacific Heights, Berkeley hills and Marin County, but definitely not City people I know. Nobody spends that kind of money anymore on luxury fashion and her customers are dying off. Our fans want street fashions they can wear anywhere, not just at weddings and formal events."

"But you're no different than mom," I say. "Your Goth outfits cost up to $10,000. How can she adapt to the times?"

"I keep telling you – street kimonos – like Yayoi Kusama who has a deal with Louis Vuitton."

"But she's famous. Nobody knows mom outside the Bay Area."

"She needs to up her game."

"How?"

"Cosplay. That's the only global fashion game in town today. Maybe mom can design street kimono cosplay outfits. I can add an upscale line of Goth kimono line and leathers."

Mari bursts out laughing.

"I'm just kidding. There's no way in hell mom will ever do that. She's stuck in Heian Kyoto, at best Tokugawa "Shogun" styles. Her clients would laugh all the way to the dump. I'm not going to bastardize my fine Goth line with frilly kimonos. My clients would think I've gone crazy."

"You are crazy -- you and your Hell's Angels buddies and clients. Everyone in Japantown fears that they'll tear up the town with their big hogs."

"Hey, don't be butch. They're law-abiding bikers. They just like big machines and need to wear thick leathers to avoid injuries. God, you're so pampered and out of it. On the road, you need to be protected from the weather and pavement."

"OK, I get it, but you don't have to be so mean to mom. What did she ever do to you to warrant your rough treatment?"

"Where have you been? Remember all the goddamn frilly kimonos she decked me out in? Like a Christmas tree. In fact, dad told me that Japanese parents dress up daughters like Christmas trees to marry them off before they become old maids. Just like mom. There's no way in hell I'm ever going to let her dress me up in a frilly kimono to marry me off to some idiot suit. I'd rather bike with my buddies across America, free and happy, than sit in some stupid ceremony like a "Shogun" maiden waiting to be married off to some aristocratic dweb."

"Wow, you really inhaled."

"Everyday, man. How else can I put up with all this shit about getting a decent job, wearing kimonos, bowing like a hai-hai girl, and faking smiles all the time. I hate it. Your typical Japanese American "Model Minority" stereotype imprisons us in a straitjacket, like we never left the WWII camps. I can't stand all this bowing and fawning and smiling to please people. It's so fake. I just want to be the real me, honest and authentic, a Goth designer and biker who

loves biking across America, like my biker buddies and our City's hero -- Jack Kerouac – who set out to see America with his Beat buddies. That's the real America for me – total freedom and the open road, not some stuffy kimono shop in faux Japan."

"I'm sorry you feel that way, but I get it. I want to design robots, but kimonos and Bunraku get in the way.

"You're young. Just suck it up and *gaman* (persevere). When you're older, you'll get your chance to shine. Until then, just help mom and learn business so you can fly on your own. Eventually, mom will retire and rely on us for her retirement."

Mari gives me a big sister bear hug, squeezing me so hard between her buffed arms that I cannot breathe. She pushes aside her purple locks on the right side of her head, which is half butch on the left side. I always wondered why she likes styling her hair that way but just shut up.

"Brad, you're just a kid. You don't know what you don't know yet so listen to others -- mom, Steve, and us girlz. We've all been through a hell of lot more than you realize. If you watch, listen, ask questions and learn, you'll be wiser when you grow up and not screw up like we've done so many times. Like mom and dad, we all want you to succeed, but you've got to study and train hard before you become a warrior. You've got to be a tough samurai if you want to survive as an artist or inventor."

"You sound like dad."

"Who do you think inspired me, coached me, and actually went out and achieved his dream? He's still my hero. He was crazy and defied his parents, but he did it."

Mari sniffs, all teary eyed. She was dad's favorite so she was his little shadow who followed him around everywhere. She grew up tough and strong, like him, and she misses him so much that she often cries at night, like mom -- two samurai who cry a lot. I hug her tight.

"Someday I want to be like you," I say. "Fearless."

"Just be yourself. Be real."

5

MELTDOWN

Our pop-ups launch with a roaring start. Hundreds of our friends and fans see our exhibits at the GOBO hub so we run out of cookies, tea and products. We are so giddy that we are floating on cloud nine. Mari and Emi are excited with the warm reception to their new fashion lines and local journalists give them headline coverage, but launching new fashion lines is easier said than done. After the first few weeks, the crowds start petering out. We only attract diehard fans and a handful of windowshoppers who happen to drop in and pick over the Goth and cosplay outfits but walk out emptyhanded. It is frustrating. Mari and Emi spend hundreds of hours crafting their prized outfits but sales fizzle like end-of-the-summer bargain basement sales. What do we do now? How do we avoid the common trap of starving fashion designers, filmmakers, and tech startups coming to the City with stars in their eyes then totally bombing and vanishing like the noonday fog.

"Guys," says Mari. "We're not cutting it. How can we attract new customers?"

"More social marketing," I say. "How many followers do you have?"

"A few thousand, but they've already seen my ads," says Emi. "They aren't enough to drive walk-in traffic and sales. We need something big that will attract new fans."

"Any ideas?"

"How about a Halloween special?" says Yumi. "I can post AI avatars of Goth cosplay fashions to tap more teens."

"What type of designs?" asks Mari.

"Something morbid like "Night of the Living Dead." The more gruesome, the better."

"Barbary Japantown!" I say. "I can create a Bunraku version from my old shows and add Yumi's avatars."

"Let's try it. We need something to drive traffic. Thankfully we're not doing it in mom's shop."

We create a Barbary Japantown ghost town, like it was during Covid-19 lockdown, but make it over-the-top like a Japanese ghost story with ghouls and zombies floating around in a deep fog. The scenes at our pop-up and website are perfect – dark, eerie and haunting – with the distant sound of foghorns and clanging cable cars mixed with the thump-thump of hard rock music. Mari creates a cool line of Goth fashions with black leather and whips that look like something out of "Friday the Thirteenth" with the Hell's Angels thrown in for good measure.

"What do you think?" asks Mari.

"Good, but you need more gore," I say. "Like a gang war between two motorcycle tribes."

"I don't think the Japantown folks would appreciate biker gangs -- too street. Why not the opposite? Why not cyclists helping old ladies, like off-road cyclists do? We could invite them to show their bikes."

"Whatever works. We just need more foot traffic."

Our wish comes true on a bigger scale than we wish. On Friday night opening, Mari's biker fans show up in force. Within hours, sixty bikes line the streets around Japantown. It looks like a biker rally. Then, to top it off, the Hell's Angels show up. Within an hour, fifty Angels driving huge hogs come roaring up Geary Boulevard and gun their engines as they circle Japan Center and the Peace Plaza. People are terrified, especially old ladies. Before we know it, over three hundred bikers have descended onto Mari's Goth exhibit at GOBO center, buying out her latest fashion line.

"Yea!" cheers Mari. "We're a total success! I'm completely sold out. Emi too. We need to do more biker nights."

"I'm not sure about that," I say. "It might be difficult with Japantown leaders."

"Why not? It works. You're just jealous that you're not selling more robots. You should host your own robot nights."

"I'm not jealous, just worried. Take a look outside."

We look outside and see an armada of SF Police Department motorcycles lined up like the National Guard. We rush outside to

find a standoff between the cops and the bikers. The Hell's Angels taunt the cops. Mari rushes to their leader.

"Guys," she yells. "You can't park here! There's no cycle parking. Park across Geary in the open parking lot."

The Angels sniff at Mari and laugh, pulling up to the cops and grinning. Mari runs over to tell the leader to move on. He refuses. Mari begs but he will not budge. A cop pulls up and tells him to move on. He refuses.

"We want to buy her Goth jackets," he says, grinning with his sharp teeth protruding like fangs.

"I'm all out," replies Mari. "But you can leave a deposit and I'll make a special custom jacket just for you."

"Sir," says the cop. "Can you move on?"

"I'm ordering a jacket from the lady."

"As soon as you pay, please move on with your buddies. You're blocking traffic."

The guy gives Mari five hundred dollars and his phone number. She smiles and thanks him. The biker nods and moves on, gesturing for his buddies to follow. They all leave.

"Whew," says Mari. "That was a close call."

"I wouldn't count your eggs before they hatch," says Yumi.

"Lady," says the cop. "I wouldn't sell your leathers like this. It's the wrong crowd for Japantown. Find another place it where they won't block up the streets and scare people."

"Yes, officer," says Mari, biting her lip.

A concerned shopkeeper walks up to Mari, with a deep frown on her powdered face. It is Mrs. Tamino, the owner of a cosmetic store across the street.

"Mari," says Mrs. Tamino. "We all appreciate your efforts to revive Japantown, but we're concerned about all the bikers coming. Can you not advertise so much or sell elsewhere? We don't want Japantown to become a biker haven."

"I'm sincerely sorry," says Mari, bowing deeply. "I promise that this won't happen again. We'll just keep my events small."

Mrs. Tamino looks at the Hell's Angels and biker club members gunning their engines and roaring up and down the street.

"I hope so – and soon."

She bows slightly and walks off to join other upset shopkeepers.

"Looks like we need to scale back our marketing," I say. "Less is more."

"Maybe we should rent a pop-up elsewhere for a while."

"For Goth fans, I think that would be a good idea."

Our next move at GOBO Center is to promote Emi's cosplay business, which should be easier since she targets playful teens who cannot drive yet, at least that is what we thought. On her opening day, we are inundated by teeny-boppers (do people still use that word like our dad did?) – boys and girls dressed up in a flurry of cosplay outfits – supermen and supergirls, French can-can dancers, Japanese school girls, Gozilla and Rodan, samurai and calypso singers.

"Looks like we have a go," says Emi, dressed in her latest Victorian queen outfit, flashing a huge crescent smile that fills the room. "I can't wait to go online. We'll be drowning with fans."

Yumi creates cool AI avatars of Emi's cosplay fashions, which scamper about her virtual scenes like anime characters. YumiLand grabs attention; before long the buzz is overwhelming. Girlz and boyz fill Emi's virtual exhibit like honey bees seeking their perfect outfit. Emi is in seventh heaven. She helps girlz put on outfits and twirl in front of full-length mirrors we set up to create a looking-glass world.

"We're Harajuku West!" says Emi, raising her hands and spinning like a top. "My dream has come true!"

Her fans surround her and cheer so I straighten out the long tail of her gown so she can stride like a queen. We are on top of the world.

Outside, mom is looking into our pop-up with sad eyes. I go over to invite her but she declines.

"What's wrong, mom?" I ask. "Has something happened?"

"Nothing," she replies. "Nothing at all."

"Then why the long face?"

"It's nothing, nothing at all. I just wanted to see how you're doing."

"Smooth as silk. Better than we hoped."

"I'm glad to hear that. Perhaps we can do the same."

"We?"

"Kimono Minds. I'm planning a new fall collection and need your help."

"I'm kind of busy now with Emi and Mari. Can it wait?"
"OK, I guess so."

Mom turns and walks back to our shop without dropping in to congratulate Emi. I chase after her, but she turns me away.

"Just help Emi and Mari. I can wait."

Mom walks off, scurrying with her head down. I chase after her but she waves me away. I stop, looking at her walk into our shop and shut the door. The leaves falling in Osaka Way blow around the sidewalk in little whirlwinds and pile up at the entrance of our shop, making it look sad and abandoned.

6

REGATHERING

Our little experiment in pop-up retail worked but is not sustainable. After a flurry of social marketing and busy weekends, our foot traffic drops to almost zero. Even on a good weekend, Mari and Emi only sell a few hundred dollars, hardly enough to cover costs for materials and rent. My robot pop-up business is going nowhere. We are all going bankrupt so we stop hosting pop-ups to save money, regather our strength, and figure out what to do next.

"It looks like pop-ups don't work as well as I hoped," says Mari. "A few weekends of biker gatherings then total silence. It's like everyone is avoiding me so I don't feel bad about our slow sales."

"Me too," says Emi. "Yumi and I are marketing like hell, but our traffic is almost nothing. It's a good thing we only tried pop-ups or rent would kill us."

Now we know what mom and dad were talking about all these years. It is tough to be a shopkeeper and keep the doors open. Fashion is a discretionary purchase so people only buy gifts for holidays, birthdays, and events, which is not enough to sustain sales like restaurants or grocery stores. We are stymied. How can we build sustainable businesses? Where are the opportunities? How do we achieve them without spending much money? I wish we had asked dad more questions when he and mom were busy building Kimono Minds and our Bunraku theater. Retreating is a no-brainer until we regather and reposition ourselves. But then what?

My sisters and I sit around brainstorming ideas about ways to generate more traffic and sales, but we can't think of anything cheap and easy to do. However, mom does.

"Look, girlz and boyz," she says. "You made a noble effort and learned how hard it is to run a fashion business. Now you know what your dad and I faced for the last thirty years. It's amazing we

even survived with four mouths to feed."

"Mom," says Mari, bowing deeply to mom. "We appreciate your efforts. It must have been hard. How did you do it?"

"We worked hard day and night, but we were lucky. Japan was hot and kimonos even hotter. I was the Kimono Queen and your dad the Bunraku King. We could do no wrong. The media called us the royal family of Japantown. We were wined and dined and appeared in fashion and art magazines around the world. Those were the good old days when we were young and crazy and could do anything we wanted, but those days are over. We baby boomers are aging. We are tired and don't have much money anymore. Our customers have moved on, retired, and died. You Millennials and GenZ don't appreciate kimonos and traditional arts. All you want is J-Pop and K-Pop. That's why I keep asking for your help to reinvent Kimono Minds for the future."

"How about street kimonos?" asks Mari. "I'm beginning to see women wearing recycled kimonos redesigned as flashy coats, like the polka dot ones designed by Yayoi Kusama."

"Maybe we can get a corporate sponsor too," says Emi. "And launch a Street Kimono line."

"I'm afraid I'm too old and traditional for that. It's for young people like you."

"We'll help you," says Emi. "I'll get my cosplay friends to redesign old kimonos for the street."

"And I'll design Goth kimonos," says Mari.

"I'm not sure that will work. It will turn off my customers."

"But your customers aren't buying enough," I say. "Maybe Emi can sell them as cosplay outfits and market it under her brand."

"What about Kimono Minds? What can I do?"

"Just supply used kimonos and we'll do the rest."

"Are you sure this will work?"

"Nobody knows but it's better than nothing. We can't afford to do nothing. Let's go for broke. That's our only chance."

Mom looks frightened and uncertain, biting her lip and wringing her hands. We all give her a big hug to cheer her up."

"It's all for one and one for all!" says Yumi. "We either hang together or hang separately."

7

STREET KIMONOS

There is one benefit from facing bankruptcy: it focuses the mind. Mom, my sisters and I are failing and we do not have rich friends or financiers to bail us out. People say they love our beautiful kimonos and cool Bunraku shows and how great it is we are preserving Japanese culture but they rarely buy and have no clue about the financial difficulties facing us. We are barely surviving. Our fans cheer us on and give us their two cents worth of advice as armchair artists and shopkeepers, but do not realize how hard it is to perform at the highest levels with little money. Art does not just appear like magic; it requires decades of sweat and toil. We are constantly learning and reinventing ourselves. Our challenge is not creating, but surviving. How do we find new business ideas to survive? Mom and dad rode the "Japan Wave" in the 1990s. Today we have a "J-Pop Wave" among young people but will it last? The field is glutted. The big Japanese retail chains have mastered J-Pop and K-Pop marketing and are moving superstores into the City. How do we differentiate ourselves and stand out with micro-budgets? Perhaps Mari's ideas of street kimonos, like her Goth biker fashions, could work but we are nobodies and mom's kimonos are so traditional and blah that young people would never wear them.

"Girlz," I ask. "What kind of street kimonos would you and your friends wear?"

"Goth kimonos!" says Mari. "For cross-country biking."

"What in the hell is a Goth kimono?" I ask.

"Leather jackets and pants with bold kimono patterns sewn into the arms, legs and back."

"Like sports decals."

"Way cooler. With gigantic Hiroshige waves, bold Mu circles and scowling Noh mask designs."

"Who would wear that?"

"Asian dudes and their girlfriends who want to show off their identity in cool ways."

"There aren't that many Asian bikers. They're all studying to be doctors and engineers."

"They drive fast cars. You know, like "Fast and Furious." Wimps will buy anything to wow their girlfriends. We can make macho images with Toshiro Mifune and Bruce Lee to create an Asia Cool Look."

"What about you Emi?"

"That's easy. My cosplay fans already look cool. They just need old kimonos to cut up and redesign with other materials."

"Like what materials?"

"Hemp, Indian saris, Mexican and African fabrics, plastics, jewelry, anything leftover since my friends and I are into regenerative fashion."

"Can you explain more? It's just a buzzword to me."

"We take recycled clothes, fabrics, plastics and other trash and refashion into our cosplay outfits. It's free since we're dumpster divers and hit up Goodwill, used clothes stores, yard sales, and stuff left on the curb. We're even using new biomaterials."

"Like what?"

"Hemp, cotton, and silk are traditional biomaterials. Today, we're using banana and orange peels and growing new types of biomaterials. It's a booming industry."

"Can you use it as fertilizer after it's worn out?

A slight pause as my sisters frown.

"Just kidding. Can you make Christmas cosplay designs?"

"Anything you want. We only have a few months so we need to move fast. Will you organize our pop-ups?"

"Anything to avoid bankruptcy. I have an idea for our branding. Let's call our show "Street Kimonos Live." We can show young people wearing cool street kimonos around Japantown and the City. Make it chic and hip. Very San Francisco."

"The San Francisco J-Town Look!" says Emi. "I love it! I can create my whole line around it."

"I'll call my line Gothic SF," says Mari. "We can target Noir SF thriller, mystery and crime fans, but make it hipper."

"I'm not sure Japantown folks would appreciate Goth after

the biker incident," I say. "Can we do something less controversial to avoid attracting biker gangs?"

"Your Bunraku fans love samurai blood and gore so why not show good old Barbary Coast blood and gore. It's all around us with anti-Asian hate crimes."

"I'm not sure glorifying violence is a good idea."

"Look, it's for Halloween. We can clean up our act for Thanksgiving, Christmas and Oshogatsu (Japanese new year)."

"We need to be relevant instead of living in the kimono past like mom. We need to be modern, hip, and cool or our fans will totally blow us off."

"OK, capitan. Let's go for it. Go for Broke time"

"Or go broke. It's a no-brainer."

Re-energized, my sisters scoop up all of mom's old kimonos sitting on the racks, cut them up into fashionable, new designs, then add recycled hemp, silks and cottons to create Mari's Gothic SF leather line and Emi's "J-Town Look" cosplay outfits. Mom freaks out but her old kimonos are not selling. Within a week, our shop is overflowing with the coolest street kimonos ever seen in the world. We are even hipper than Harajuku and Paris. In fact, the word gets out and fashion photographers, bloggers and journalists show up to shoot photos, air streaming videos with their models, and interviews with Mari, Emi and mom. We are suddenly hot again. I organize pop-ups with fashion shows hosted by mom, Mari and Emi and we invite our fans and the fashion world.

Like manna from heaven, the City responds with an atmospheric river of fans, journalists and customers who buy out everything we have. Overnight, we are finally in the black so Mari and Emi have to make more street kimonos, but mom is out of old kimonos so they need to scramble and find new materials. Mari, Emi, Yumi and I become dumpster divers par excellence and raid every dump site in the City and, not finding enough materials, pan out to other Bay Area cities. But the competition for textiles is fierce since many cosplayers copy us and create their own lines. They move in hordes, swooping in and vacuuming up everything like locusts. Mari laughs, calling their raids "The Day of the Locust." But for us, it is not funny; it's survival. Mari and Emi must find more untapped sources or we are out of business.

"Damn," says Mari. "The Bay Area folks move so fast. It's

hard to keep up."

"There are a lot of poor folks looking for work and we just showed them the brass rings."

"What do we do?" says Emi, with a look of despair. "I thought we would be a screaming successs. We'll be lucky to survive in the tidal wave of regenerative fashion copycats." Any ideas?"

"Let's hunker down and put our Kimono Minds together. We'll think of something. We have no choice."

8

DAMSELS IN DISTRESS

I do not know whether to laugh or cry. I am just a high school kid but responsible for making sure my crazy kimono mom and crazier wannabe fashion designer sisters avoid bankruptcy. We are standing at the edge of eviction. With interest rates high and our credit card debt climbing, we are in serious trouble unless we figure out something fast. My buddies call us "damsels in distress" and I am the white knight who is supposed to rescue them all. Why me? I just want to be a robot designer, not a financial engineer or repo man. I have no training in finance and economics, just hands-on experience building puppets and robots, running our Bunraku theater and shipping mom's kimono. I am hands-on, not a strategist. What should we do now? What is our future? Do we even have a future? Family shops are falling like dominoes so I need a mentor – and fast.

I call Steve Durbin who is our only hope. He shows up promptly after work and we walk up Fillmore Street to talk frankly without half of Japantown listening in.

"We're going under," I say. "I promised my dad that I would help mom, but Kimono Minds is going under. We can't even pay our back invoices, despite our recent successes."

"I know the feeling," says Steve. "When I launched Virtual Fillmore, I was drowning in bills. You're doing your best. Retail is tough. I started during the VR boom. Today, half of our mom-and-pop stores are failing due to remote work. Virtual stores are doing even worse since everyone is focused on AI, not VR. It's not easy for anyone."

"What can I do? How do we survive? You've built Virtual Fillmore into a unicorn and are still thriving. How do you do it?"

"Brick-and-mortar was dying even before Covid-19. Interest rates and operating costs are so high that physical stores are shutting down, even in Beverly Hills. You've got to go virtual or you're

dead."

"What about our shop?"

"It's OK for some walk-in traffic and design work, but not for survival. I can help you go online."

"How?"

"With cool content. Online Bunraku shows and fashion shows are still unique so you can attract eyeballs with cool 3D shopping to sell everything you can."

"Like what?"

"Your puppets, your mom's kimonos, your sisters' fashions, online videos, music festivals -- anything that grabs attention. Today, all retail is showbiz; either show to entertain and educate people or you won't get the biz."

"But that will cost a fortune."

"Don't worry. You can use my Virtual Fillmore platform to create your virtual shop. My designers can knock out 3D models of Kimono Minds and your sisters' pop-ups. They're getting bored with the same old Fillmore jazz themes. They need something fresh and challenging."

"Awesome. How long will it take?"

"A couple of days to create Kimono Minds and AI avatars of your mom's kimono models and your sisters' fashions. It's like a jazz stage – place and people."

"How do we get paid?"

"On my e-commerce platform. The hard part is figuring out what products to sell. You need to test and see what sticks."

"How many products?"

"Start with just a half dozen fashion styles. Something catchy since the Web is saturated with me-too fashion. You've got to be unique and constantly refresh your fashions until you discover which ones sell. E-commerce and entertainment are fiercely competitive so pick the coolest stuff and see what sticks."

We stop at the top of Fillmore and look at the bay below, which has a spectacular panoramic view of the Golden Gate Bridge, Marin highlands, Sausalito, Angel Island, Alcatraz and the Berkeley hills. After weeks of sleepless nights, I feel hopeful again. I grab Steve and give him a big hug.

"Thanks, bro," I say. "We're indebted to you. Without you, we would be history."

"Don't count your chickens before they hatch. You've got a lot of hard work to do, but if you focus and work hard, you can survive. It won't be easy, but I did it. You can too."

Steve pauses and pulls out a small netsuke wood carving of a Maneki Neko cat with its right paw up, which shopkeepers put at the entrance to welcome customers.

"When I launched Virtual Fillmore, your dad gave me this good luck charm. He said I could succeed if I ignored the skeptics and critics and focused on building the coolest Fillmore jazz website in the world. He was right. It was tough; we almost went bankrupt many times, but we survived because I never lost hope and gave up. When I felt like quitting, he grabbed my shoulders, stared into my eyes and said: "Go for Broke! You're heir to a double legacy -- the 442nd/100th Infantry Battalion and the all-Black 92nd Infantry Battalion from WW2. Despite racism, setbacks and defeats, they beat fascists then battled racists during the Civil Rights movement." Without your dad's support, I never would have survived the constant humiliation as a poor Black-Japanese kid. I was a total nobody and mocked and feared by all sides for who I am. I would have ended up like many of my buddies -- in prison or dead. I just want to pay back your dad's kindness – ongaeshi, Japanese style."

Steve gives me a big, fatherly hug, his body trembling, and lets out a quiet moan, a deep moan that I have never heard from him, a moan that reaches back to his childhood and centuries of mockery, fear and hatred, of slavery, Jim Crow, WWII concentration camps, racial profiling and daily insults, which he mentioned but never discussed in depth. For the first time, Steve breaks down crying. I hug him tight. Now I know why he succeeded. He never gave up. He took my father's netsuke, hunkered down and drove hard until he succeeded. I need to do the same.

Steve points to Angel Island and Alcatraz.

"You see those islands. They are symbols for our communities. Angel Island was the interrogation center for Chinese and Japanese immigrants. Alcatraz was the prison for many Black inmates and the site of the Native American protests during the 1970s. Both sit on Turtle Island that we occupy from the Ayatusch Ohlone peoples. Japantown and the Lower Fillmore sit on all of them. They are the islands of our people. Once they were ethnic ghettoes since we could not live in white areas. Now they are our

remaining lifeboats. Without them, our communities will die culturally and spiritually. We cannot let the City and big developers eliminate us like the past. We must fight to keep Japantown and the Lower Fillmore open. You must fight to keep Kimono Minds and your sisters' shops open. We are the new "Go for Broke" warriors sitting on the shoulder of giants. We are facing off with some of the biggest, richest and most powerful billionaires and corporations in history. We cannot let up. We cannot quit."

9

VIRTUAL KYOTO

With Steve's Virtual Fillmore platform, setting up our virtual shops is a snap. Our big challenge is figuring out what fashions to show and how to present them. As mom says, presentation is everything. She suggests studying fashion, food and travel websites for ideas from Japan. We cannot read Japanese fluently so we use online translators. Our research is a virtual tour of Japan, mostly 2D sites, but we come across J-Pop sites with 3D games and shopping malls so we study them carefully. It is a good thing Emi loves J-Pop and Yumi creates AI avatars. They save our favorite sites as design references. Our favorites are Tokyo's Harajuku district jumping with cosplayers and Osaka's Dotonbori restaurant row along the canal flashing with neon lights.

"Let's start with my Goth fashions and Emi's J-Pop cosplayers," says Mari. "We need to grab attention fast. Once we have fans, we can introduce mom's kimonos."

"What about my robots?" I ask.

"Create AI avatars, make them cool and we'll dress them up in cool fashions – the SF Look. Remember, we're a fashion shop, not a robot toy store."

I am deflated, but at least my sisters let me showcase some robots as AI avatars and bots.

"Why don't you show your latest Bunraku puppets as bots?" says Yumi. "They are beautiful, historic and unique. I can create AI avatar versions. Just give me the files."

I supply a few of my best Bunraku puppets – Chushingura from dad, my 442nd/100th Infantry Battalion soldiers from World War II and San Francisco skateboarders. Yumi knocks them out fast and clothes them in cool samurai armor, GI fatigues and hoodies.

Mari provides a menacing Goth look, like warriors emerging from battle.

"Very realistic," says mom. "But what about my kimonos? I thought you were trying to save Kimono Minds, not scare our customers away with demons."

"Sorry, mom," I reply. "We got carried away. We'll add your kimonos. I have an idea: Let's call our site "The Chrysanthemum and the Sword." We'll show your beautiful kimonos in a garden of chrysanthemums with links to Goth samurai bearing swords."

"Isn't that too violent for a kimono site?"

"Not at all. "Shogun" shows samurai and kimonos so there was no contradiction. That's how Japanese royalty lived in the past."

"That was the Tokugawa era," says mom. "I want to show the grace and refinement of Heian Kyoto when my family began designing kimonos. We Moriokas go back a long way, even before Heian, so we need to show our heritage proudly."

"OK, mom," says Yumi. "We'll focus on recreating Kimono Minds with a Heian look."

"That would please our customers. They absolutely love the Heian period."

"Then we'll create a Virtual Kyoto with your kimonos worn by princesses in elegant Heian surroundings."

"Virtual Kyoto? You can do that?"

"With VR, we can create anything. Imagine beautiful temples, shops and naminoki houses in Gion filled with women wearing gorgeous kimonos who are protected by palace guards."

"Perfect," says Mari. "I can dress the guards in Goth armor."

"But they didn't have Goth design then," protests mom.

"We'll just modernize it a bit for my customers since they like a little romance thrown in. A Heian Goth Look would be fresh and unique, like J-Pop cosplay characters."

Mom shakes her head.

"You girlz never quit do you. Always Goth and cosplay, never traditional Japan."

"Mom," says Emi. "We need to make Kimono Minds relevant for young people today. Your customers are aging and passing away. If we don't create designs for young people, we'll have no customers left."

My sisters gather around mom and beg to have their Goth,

cosplay and AI avatar designs integrated with her Heian Kyoto Look. Mom looks at me, shaking her head in resignation.

"I give up. You girlz win."

My sisters cheer.

"But make it authentic, like Heian Kyoto, please."

"We'll do anything to keep our little shop alive."

Mom smiles, the first time in weeks. She jumps in, delighted to help us create Virtual Kyoto. She picks her favorite Kyoto scenes and Yumi's gamer friends create 3D models of Heian buildings, shops and streets using VR. Our Virtual Kyoto glimmers beautifully like chrysanthemums emerging from the dark green forests around it. Mom jumps up and down like a kid.

"Hontoo! (really)," she says. "That's where I grew up next to Yasaka Shrine in the Gion district, which goes back to Heian. Natsukashii! (I'm homesick). I wish I could go home now."

"You can," says Yumi. "You can visit Virtual Kyoto online anytime you want."

"But that's not like being there with my friends."

"We can add them too as avatars."

"Like Brad's Bunraku puppets?"

"Yes, except as Heian princesses and princes. Think Genji and his many lovers."

"Isn't that too loose?"

"Don't be a prude," says Mari. "Even Heian royalty flirted and played around. We need to show it, not just kimonos, or visitors will get bored fast."

"Not kimono lovers. They'll spend all day looking at girls to pick the best one."

"Maybe women will be looking for their prince charming too, like Genji," says Emi. "You can even find a handsome widower."

"I'm not looking for a husband, just sales," says mom. "But you win. We'll have beautiful Heian kimonos and dashing Genji princes to attract young women. My girlfriends will be shocked."

"We can add older princes for your divorced friends."

"Oh, no. AI avatar lovers! My friends will never forgive me!"

"It's all fantasy anyway," says Yumi. "I thought you always said beauty and romance sell kimonos."

"I did, but let's at least make it respectable. I don't want any

scandalous gossip."

"Are your girlfriends that hard up?" I ask. "I thought they were prim and proper like you."

"Well, not all of them. You know they have feelings too."

"Yes!" says Mari. "Now we have a hook to attract kimono lovers, young and old – ROMANCE – in all capital letters."

"No, no, no!" says mom. "That would be too much. Can't you make it more subtle and refined, like Heian princes and princesses?"

"I read they were a rowdy bunch," says Mari. "Riding wild horses like my boyz ride wild motorcycles and chasing women behind the elegant painted scenes. At least what grabbed me when I read "The Tale of Genji."

"OK, you're right. Men will be men; women will be women. They wore elegant clothes, like today, to attract the finest and most refined lovers. We'll do the same."

"Yes!" shouts Mari. "My biker bros and girlz will pile in if we show cool horses and bikes. Dashing Heian bros wearing Goth riding fashions just like my Harley bros!"

"Oh my goodness," says mom. "What have I unleashed? Virtual Kyoto will go crazy."

"Don't worry, mom," says Yumi. "We'll only show the refined Heian Look kimonos. The real action will happen behind the screens, just like Heian Kyoto."

My sisters burst out laughing. We thought reviving Kimono Minds would be boring, but now it looks like it will be a blast, like creating a Big Game costume party at Cal for online dating. In fact, Yumi suggests launching it before the Big Game to grab visitors.

"I'll call our launch "Big Heian"," says Yumi. "Complete with Heian princesses and princes riding stallions and modern bros and girlz riding Harleys. We could even get Japanese motorcycle companies as sponsors. That would grab everyone's attention."

"Arigatou gozaimasu (thank you)!" says mom, hugging us. "We have a chance to survive as a family and a business."

"You mean businesses," says Mari. "We're all launching businesses that will survive."

Our Virtual Kyoto comes up quickly since we are all motivated to

launch our own businesses. Yumi's Cal coders create a realistic Heian Kyoto palace filled with AI avatars of princesses in flowing kimonos. She scans in the faces of mom's girlfriends and puts them onto their avatars so they look real."

"Can I talk with them?" asks mom.

"Like Brad does talking with the dead," says Yumi. "I'll use them to research the backgrounds of your family and friends so we can train their avatars to talk realistically. It takes time to train the avatars, but soon you'll be able to talk with anybody – family, friends and celebrities, living and dead, or animals."

"My cocker spaniel Mika when I was a kid?"

"Mika too. We can even dress her up in a dog kimono."

Mom smiles.

"I want to show my friends. How soon can you create it?"

"In a day if we have photos of their faces."

Mom pulls out old albums of her school classmates and we scan them into, put them onto avatars then lip synch the faces so they talk like real people. Yumi's coders create a modern Kyoto to show mom's friends, which is linked to Heian Kyoto so visitors can walk into the Heian palace to see Genji and his lovers.

"Hi, there," says Yumi, showing mom's best friend Miya. "How's Kyoto? Busy with tourists?"

"Yes," replies Miya. "It's April so the cherry blossoms are blooming and the city is packed with tourists. But we miss your mother. When can she visit us?"

Mom breaks down crying, sniffing and wiping her nose, as Miya guides us through the Gion district to Yasaka Shrine. Yumi has scanned in mom's kimonos and dropped them onto AI avatars praying at the shrine.

"I can't believe it. I thought I would never stay in touch with Kyoto, just visit when I could afford it. I haven't gone in nearly a decade since dad and I never had the money."

"Now you can visit your friends in Kyoto anytime. That's why we use VR. It's like an immersive TV. You can walk around Kyoto and talk to any AI avatar that you want – friends or historical people. We can create anything you can imagine."

Mom sits back, stunned. She always thought we kids were crazy about gadgets, but now she realizes the power of VR and AI. She can visit friends in 3D and create our Kimono Minds shop in

Virtual Kyoto as if it exists for real.

"Can I sell my kimonos online?"

"Anything you want – kimonos, tabis, obis, scarves, capes, anything at all."

"This is a godsend. I wish I had it when I came to San Francisco in the 1990s then I would never have lost touch with my family and friends."

"It's not too late. Just start selling your kimonos and invite your friends around the world to shop at our virtual shop. They can be anywhere, see any virtual product, request new designs, and even upload their own textiles to see how they would look as kimonos."

"That's magic. Why hasn't anyone done it yet?"

"Only a few big fashion brands, but the VR Metaverse is still off until cheaper VR glasses and visors become available. Meanwhile, we all use tablets, laptops, phones and TVs to see and navigate through our 3D scenes. You don't need headsets unless you want to immerse yourself into the scene. It's like stepping off a bus instead of viewing the city from the bus through windows."

"That's too technical for me."

"Don't worry. We'll make it easy for you and our customers. Our Virtual Kyoto and virtual pop-ups for kimonos, Goth and cosplay fashions will be a first in San Francisco and Kyoto, perhaps in Japan and the U.S."

"Wow, so we can be leaders?"

"Your wish is our command."

"You're my genies and geniuses! I love you so much."

Mom gives us a big group hug. Finally, we have reconciled our split with mom. I hope it runs smoothly to avoid squabbles since we are just beginners and have no role models to copy.

"Kyoto builds the future on the past," she says, repeating her favorite line.

"We will build Virtual Kyoto onto real Kyoto and meld the two digital twin worlds into one," says Yumi. "In other words, one merged world."

Mom frowns, looking confused.

"I never have to leave Kyoto?" she says. "And we can bring it to everybody around the world?"

"Exactly," I say. "In real time."

Part 2

Reinventing the Present

10

VIRTUAL POP-UPS

Mom loves Virtual Kyoto, which does a booming business since Yumi's team designed it not just for flat panels, but also VR headsets that allow visitors to navigate through Heian Kyoto temples, palaces and gardens as if they are there. We invite our friends, especially skeptics, to virtual tours of Kyoto and night parties in the Gion district, which turns Virtual Kyoto into one gigantic party town with Yumi's Cal friends pouring into the palaces and streets as AI avatars. During the Cal-Stanford Big Game weekend, Virtual Kyoto goes crazy with students wearing wild psychedelic and neon cosplay kimonos that flicker like fireflies at night. Mom is so overjoyed with Virtual Kyoto that she forgets to invite her friends to our real world shop.

"This is so much fun," she says, dressing up her avatar in an elegant kimono with a long trailing tail only a bit longer than her long virtual black hair. "I wish I had this as a girl. I would have stayed in Kyoto."

"But you would have missed coming to San Francisco and we wouldn't be here," says Yumi.

"You're right. It's just as well I didn't have VR or I might have stayed forever in Kyoto and never seen the world or have you wonderful girlz."

My sisters are delighted how Virtual Kyoto has strengthened their bonds with mom. For years, mom was afraid Yumi would disappear into the virtual ether, like gamers, and escape reality. Now mom is escaping into Virtual Kyoto with us. She is becoming a virtual nomad like Yumi.

"What about our shops?" asks Mari. "I like helping mom but

we need to promote our own stuff."

"No problem," says Yumi. "My friends and I will create virtual pop-ups for you and Emi."

"Virtual pop-ups? What does that look like?"

"The same as Virtual Kyoto but way cooler."

Yumi uses an AI tool to create avatars of bros and girlz dressed in Goth leathers riding on horses in Virtual Kyoto that zoom off and transform into Harleys for Virtual Japantown.

"Now you don't need to piss off Japantown shopkeepers with the Hell's Angels. Instead, you can invite bikers and their buddies around the world to join your Virtual Japantown biker circuit."

"Biker circuit? What will it look like?"

"We'll create Japantown as the starting line for tours of Virtual Kyoto so virtual bikers can tour the temples without causing congestion."

"Show me," says Mari.

Yumi creates two virtual Harleys and lets them roar up roads carved into the forested hills above Kyoto where local bikers ride on weekends. We watch as the bikes zoom up the steep hills and speed past trees overlooking Kyoto and Osaka in the distance. It is like time travel flying from Heian Kyoto to modern Kyoto in a few minutes.

"How did you create it so fast?"

"My gamer friends from Kyoto have a Virtual Kyoto model so they offered to open it up."

"I don't think I'm ever coming back to reality," says Mari. "I could ride above Kyoto forever searching for my shining prince."

"Don't fly over a cliff looking for him."

"I'll save him."

"What about me?" asks Emi. "How do I add cosplayers in ancient Kyoto?"

"What do you want?" asks Yumi.

"Anything retro, like Heian princesses dressed as rock band girlz."

"I have a better idea. How about girlz wearing Noh masks?"

"Why Noh masks?"

"So they can easily switch personas instead of being stuck with one face. Call your band "Noh-Noh Girlz."

"I like the sound of that. What would they play?"

"Mellow rock music using kotos, samisen and taiko drums."

"Any ideas for themes?"

"Time travel since you're taking visitors back to Heian Kyoto. You can invite players to Virtual Japantown then let them slip through a dark hole to Virtual Kyoto, like Alice in Wonderland."

"Show us."

Yumi types a few lines into the Virtual Japantown AI platform and it creates Emi's Noh-Noh Girlz rock band dressed in shimmering paisley cosplay outfits. As they slip into the dark hole, they spin and swirl through a slide chute then emerge on the other side – Virtual Kyoto – dressed like Heian princesses but wearing long silk gowns that twinkle like fireflies in the moody Heian courts. For a touch of realism, Yumi puts them on a bridge over the sparkling Kamo River flowing past mom's house in the Gion district.

Mom and Emi are blown away. Never have they, or anybody for the matter, seen virtual time travel. We are the first in the world.

"Cool," says Emi. "Can we visit any era?"

"Easy," replies Yumi. "Just type in any period and voila."

Emi types a few lines and her Noh-Noh Girlz avatar flies into the Tokugawa period, looking like a princess in "Shogun." She types more lines and they transform into flapper girlz from the 1920s, then hippies during the 1960s and Goth girlz in the 2020s.

"Oh, my god!" says Mari. "With AI, you can create the right outfit for any period."

"Just type a few lines describing the scene and mood you want."

Mari, Emi and mom look at each other, speechless, trying to understand the implications of what Yumi has just shown them.

"This changes everything," says Mari. "Fashion will no longer be the same. I won't need to spend weeks designing Goth outfits. I can type a few lines to see a new design on my avatars."

"You got it," says Yumi. "Why do you think why I'm spending so much time learning AI instead of studying old tech platforms. AI will eliminate them and create a whole new way of designing fashions and eras. It's like a digital genie: your wish is your command."

There is total silence as Yumi's words sink in. My mom and sisters look around at our shop filled with kimonos, Goth and

cosplay outfits, trying to imagine what they could do differently with AI. Instead of huge pile of textiles everywhere, they could design and test any fashion style and era without any limits. They could create entire wardrobes, no, entire galleries and galaxies of fashions. It is like giving them magic wands. Poor designers are no longer limited by money, space and time. They can create anything they imagine.

"This is definitely a game changer," says Mari, shaking her head with disbelief. "My biker bros and girlz will be shocked when they see what they can create. AI will make everything sold today look unimaginative."

"All of us will look boring," I reply. "Kids will probably do better since their imaginations are not limited by the past. They will be free to soar. We don't know how AI will change our business but it won't be business-as-usual."

"What about us designers? Will we become obsolete?"

"Only if you ignore AI. Smart designers, probably newbies not stuck in the past, will adopt it fast and create amazing outfits and fashion lines overnight."

"I can't imagine what that would look like."

"Think Gangnam Style using AI," says Yumi. "Some kid could design awesome outfits and even the music and dancing avatars. I don't think we're in Kansas anymore."

"What should we do?" asks Emi, with a worried look. "How can EmiLand survive the coming hordes?"

"Play around and experiment. The virtual fashion world of the future doesn't exist yet. We're at the starting line so we need to create it."

As Yumi's words sink in, mom begins smiling. She taps a few lines into Yumi's laptop and new kimono designs pop up one after another. Inspecting each carefully, she changes her wording and the designs morph into new designs. Mom begins typing as fashion after fashion pops up. Soon, she is typing like a speed demon. She saves each one and stops after a few minutes.

"I'm done," she says. "I have my fall collection."

"Already?" I say. "But how will you make it?"

"My friend has a 3D printer for textiles so I'll ask her to start making them. I love it! All in seconds without spending a penny on materials."

Mom pauses a moment then cheers.

"I'm free! I am finally free! No more financial worries and hassles. I can create any design and print only the ones I like."

My sisters stare at mom, humbled by her speed and creativity. She is the newcomer that Yumi just warned us about. No wonder she and dad rocked during the 1990s. They always led with new ideas, like Steve Jobs introducing iPhone to the world. For us, it is a mass awakening. I'm jazzed since AI will save us time and money. The faster my mom and sisters can get into production, the better. I'm the sales guy so I need stuff to sell -- ASAP.

"We'll have the first virtual AI fashion pop-up business in the City!" says Mari. "No more fuss and muss. We can try any ideas we want and see alternatives. I am totally blown away."

Without hesitation, my sisters begin typing away on their laptops and generate hundreds of possible designs in hours. They share them with friends for feedback and order prints of the most popular designs. Within days, we're in business. Orders pour in and we have not even rented a pop-up space. We can show our fashions online and only print the ones we sell in advance.

"I love collecting money before we produce our fashions," says Mari. "This is way better than grass! Greenfields forever!"

10

SPAM CITY

Our seventh heaven does not last long. Yumi posts Mari's Goth designs and Emi's cosplayer outfits in Virtual Japantown, but hackers arrive, one or two at first then dozens and finally hundreds a day. Soon our virtual mall looks like graffiti alley with spammers filling it with trash-talking AI avatars and samurai lopping off the heads of Mari's Goth samurai. Our website soon looks like a gaming site gone awry. Fashion bloggers tear us apart and spread the word. The mocking is so harsh that Yumi takes down our site.

"We're screwed," Mari wails, pounding her fist on the table. "Unless we stop these hackers, we have no future!"

"Ask Steve for help!" says Yumi. "He faces the same problems."

I text Steve and he replies within minutes.

"Help, we're being hacked!" I text. "Can you drop by?"

"No problem, dude. I got your back."

Within an hour, Steve shows up, looking like a security guard ready for action. Yumi rushes up, clinging to him like a frightened child.

"We're down!" she cries. "All for nothing."

"Take it easy," says Steve. "We had the same problem initially with Virtual Fillmore but we figured it out."

"How?" I ask.

"I hired cybersecurity experts who built hacker-proof walls."

"But nothing is hacker proof online."

"Not 100%, but you can stop most of the intrusions by setting up detection and vaccinations."

"Sounds like medicine."

"It is in many ways. Malware is like a virus that embeds itself in systems and lies hidden, waiting to attack or when programmed."

"Damn, this sounds like a computing course," says Mari. "We just want to show fashions, not study cybersecurity."

"You don't have to. My team can help you until you have enough revenues to hire them part-time. They're top-notch, which is why we became a unicorn a few years ago."

"Of course," says Mari. "I keep forgetting; you're first Black CEO unicorn. We could use some of your pixie dust."

"It's partly magic – our music, fashion and culture – but the rest is hardcore programming. Think box office and back office. You have a great box office but weak back office security. My team will beef up your backend."

"I can't believe how fast you guys operate," says Yumi. "My Cal bros and girlz take days."

"Online, you move fast or you're toast. Your bros are newbies. We pros eat, drink and sleep tech 24x7. Our cybersecurity AI will monitor your site and alert you when things go wrong."

"How long will it take to set up?" I ask. "Our site is a total mess."

"A day or two. Just rest and be ready to reload your fashions in two days. My team time can stress test your site and you should be good to go."

Steve clicks through out fledgling site and smiles. My sisters and I sit back, relieved. Without Steve, we would be history. Now we can survive, but it will not be easy. Mari already sees hundreds of copycat Goth design sites. Emi sees thousands of J-Pop cosplayer sites.

"Your problem won't be just cybersecurity," says Steve. "It will be competitors. Once you post something, thousands of sites will immediately copy you since their AI search engines are programmed to spot and analyze competitors, then figure out strategies to win big."

"Wow, it sounds like a video game."

"Everything in retail is a real-time game today. How can you stand out from lookalike sites? How can you stay ahead? How can you host real-world fashion shows to win new fans? At Virtual Fillmore, we face that daily challenge which never lets up, but just intensifies by the hour. Everything is just faster and smarter today

with AI."

My sisters and I look at each with despair. We are definitely stuck in the past like our mom. We are tiny and not AI experts so there is no way we can beat millions of savvy retailers with bigger budgets and huge tech teams.

"I'm ready to give up," moans Mari. "I just want to design cool Goth fashions and ride with my buddies."

"You can -- once my team builds a rock solid backend. Meanwhile, keep designing."

I huddle with my sisters as we plan our re-launch.

"This had better work," says Mari. "Or we're screwed. Mom expects us to save Kimono Minds and now our necks are on the line. God, I wish business wasn't so hard. I'd rather go biking."

11

VIRTUAL JAPANTOWN

Building Virtual Japantown is easier said than done. After Steve's cybersecurity team builds a solid security wall, we discuss how to reimagine our virtual pop-up shop with the Japantown Youth Force. They are enthusiastic but so old school; they focus on helping brick-and-mortar shops recover from pandemic through traditional foot traffic, but hesitate to go virtual with 3D. It is like trying to convince elders join the 21st century. Most shopkeepers and community leaders are 70s+ so they are living in the 1970s when they were young and crazy. Even Gen Z is stuck in the 2010s. Only Gen Alpha gets us, but they are still in school.

"Japantown is stuck in the past," complains Yumi. "I can't get anyone interested in my AR and VR ideas and they wonder why they can't attract young people and gamers to their shops."

"Tell me about it," says Mari. "Try getting folks to visit my Goth kimono exhibits. They're afraid the Hell's Angels might show up."

"They did," I say. "Your events look like biker rallies."

"They're harmless. They just come for the food. Now with cops around, they won't visit anymore."

"Maybe you should stay online only."

Mari sighs. We are posting everywhere but our online and foot traffic are minimal. Young people are still visiting the Japan Center so our messaging is not working.

Yumi lives in a world of her own. She excitedly explains how she wants to use AI, VR, blockchain, and even quantum computing to "reinvent retail." She is a total geek. Our eyes roll as she riffs about her futuristic holographic Metaverse.

"The latest OpenAI interface allows us to tailor AI simulators so customers can design their own fashions," she says, pulling up the latest AI design tool on her laptop. "My GUI for 4D UI/UX is state of the art for chaotic environments. To lead, we can use photonic AI chips then quantum AI when it's available."

"Cool," I say. "They should be part of every fashion designer's toolkit."

"They will be -- in the near future."

"Meanwhile, can you come back to earth?" asks Emi. "We're losing sales now. Why do we need all this stuff? Our customers aren't nerds. They just want to buy our products. If we let them design their own, we'll be competing against them."

"We can do both – create our designs and let fans tailor them. We provide designer "look books" and offer mentoring, final design quality control, and delivery."

"So we become fashion consultants."

"Full service from concepts to final customer designs and shipments."

"Right, build-to-order. You sound like a suit."

"Remember what dad always said? All biz is showbiz and all showbiz is biz. We need to stay ahead of competitors."

"What about our own designs? We'll be spending so much time helping others that we won't have time to be creative."

"Let's ask Steve," I say. "He's dealt with the same issues in Virtual Fillmore."

Steve pops up online and listens to our worries and concerns.

"Our customers save us time," says Steve. "They tell us exactly what they want."

"But it's so much work."

"You girlz want to be trendsetters, right? You can't do it alone. You need partners, but you also need your customers giving you ideas. Study the French and Italians. They know it takes a village to make great brands and stay alive. Like me, you are your brand, not just your designs; the goose and the golden eggs. At Virtual Fillmore, we initially offered fashions then expanded into a showcase, academy, incubator, and manufacturer – like your mom was doing offline. She even gave us helpful tips about brainstorming with customers, helping them refine their designs, gathering different textiles and turning their dreams into reality."

"So our mom is fashion school, manufacturer and marketer. No wonder we were tired all the time helping her."

"It's a full-time business, but not hard once I help you set it up. Everything will be online so anyone worldwide can visit Virtual Japantown. Most can't afford to travel. Many don't want to leave big carbon footprints so you're ahead of the curve."

"How do you attract customers? Our social marketing isn't working."

"Run a fashion contest. We do it all the time."

"How does that work?"

"We host virtual contests where aspiring designers compete for eyeballs. They tailor their designs and create their own "look books" based on contest themes. To get started, focus on J-Pop, K-Pop, and C-Pop since they're big. You can add F-Pop and T-Pop."

"Filipino Pop and Thai Pop?"

"You got it, plus any other category, like transgenders, elderwear and professional outfits. Keep adding categories to offer the best selection of kimono, Goth and cosplay fashions.

"A UN of Asian Fashion."

"More open -- Latino, African, Mideast and Native fashions. Why limit yourselves when you can reach global markets."

"My head hurts," says Mari. "It's a great idea but too big for now. Let's start small since we're losing money. I just want to show my Goth designs."

"Don't limit yourself to Americans. You can show global biker designs. The sky's the limit. Harley might even want to sponsor you."

"Sponsorship? I'm all ears!"

"Now that I've got your attention, remember that you need to think bigger. The Bay Area is too small. You'll never attract enough walk-in trade. You need to reach out to global markets."

Mari, Emi and I smile, but wonder we have the chutzpah to do what Steve is suggesting.

"Just try," says Steve. "If you don't try, you never know. Don't worry about the tech. I'll make sure Virtual Japantown is cool and rocking like Virtual Fillmore."

"Talking about rocking," says Mari. "Can we add my Goth rock bands to your site?"

"Anyone you want. Invite J-Pop and K-Pop bands. We need

something big to differentiate ourselves from the thousands of other fashion sites. Let's aim to get billions of viewers like Gangnam Style."

Steve's words are a blowtorch set to a pile of hay. Inspired, my sisters move fast like a basketball team, brainstorming with Steve and our customers. Mari is the most flexible and bold, working with her biker girlz, leaving our heads spinning. Emi rallies her cosplay girlz. Yumi recruits VR girlz from around the world. My family has always been a matriarchy driven by women; I am just the behind-the-scenes guy running operations. I love Yumi's idea of creating a cosplay version of Virtual Japantown to get us out of our rut, but we have never done it before. We need to move fast, with Steve's team struggling to keep out hackers. As mom says, bills have no feelings, just deadlines and penalties.

Our Virtual Japantown relaunches like a dream. Steve connects it to Virtual Fillmore so we can share resources and customer lists. As he says: "We are seamlessly connected at the hip."

"Visitors can start their virtual tours in 1940s Virtual Fillmore with jazz clubs rocking away to the tunes of Ella Fitzgerald, Dizzy Gillespie and John Coltrane jiving away in the night when "The Moe" was the "Harlem of the West."

"We have millions of followers so invite them to Virtual Japantown via a beautiful path so you don't become "The Last Japanese Family in SF," Steve says, chuckling. "How do you like our awesome design?"

His team has created a beautiful Japanese walkway between the Japanese garden in Golden Gate Park through the Panhandle then up Webster Street through Virtual Fillmore to the Peace Plaza. It is one long, magical Japanese garden lined by blossoming cherry trees and towering bamboo.

"That's unreal," says Emi. "My cosplay friends will love it. Imagine parading virtually from Golden Gate Park to Japantown. It would be cooler than tromping through boring streets."

"And your virtual fans can wear anything they want – like Godzilla and King Kong outfits fifty feet high. In fact, the coolest stuff today is the Virtual Fillmore Look."

"What's that?"

"Check out our latest fashion show. We have an epic "Out of Africa" diaspora fashion show that follows the evolution of

African fashion since the beginning of humanity. Our designers around the world show how African designs morphed to reflect our journey through changing environments and lifestyles – from Kenya to the Mideast, Europe, Asia and the Americas."

"That's all of us."

"Exactly. We're one race that evolved from Africa so we're showing it all. It is the world's first fashion time travel show from our distant past through time to the present and our multicultural futures. We call our fashion line "Diaspora" and showcase top fashion designs along our diaspora."

Mari, Emi, Yumi and I are stunned. A diaspora fashion show? We knew Steve was creative, but the idea of fashion time travel has never been done. We usually show fashions from a few eras, as if they evolved out of nowhere and had no antecedents.

"The diaspora wasn't my idea," admits Steve. "A little girl in the first grade asked if I could show all of humanity and their clothes over time. I froze, realizing how brilliant the idea was so my VR developers created it so show the contribution of Africans to our fashion evolution from Africa to the Americas and the Fillmore."

My sisters and I sit back, awed by the hundreds of fashions through time and continents. I like the "missing link" where fashion leaps from China to Korea via Okinawa, Korea and Hokkaido – the southern, middle and northern routes into Japan.

"I don't have many Japanese fashion designs so I'm hoping that Virtual Japantown can fill in the blanks."

"You mean Japanese history since the beginning?" asks Yumi.

"Of course. Why focus just on your Heian Kyoto and Harajuku Look? Why not show Japanese fashions and their links to foreign influences since the beginning? Japan has always absorbed and adapted cultures to create a national identity. We can show it via fashion."

We sit back, trying to imagine the breadth, depth and profundity of Steve's suggestion. Has anyone ever held an evolutionary Japanese fashion show going back to its beginning? When was Japan's beginning? It is shrouded in myths and legends. We need to do an AI search to learn how Japantown fashions evolved since the 1890s, which is relatively easy to do. Going back to the pre-Yayoi period from 1000 BC will be a lot harder. Our effort would please our mother who constantly harps us about "building

the future on the past."

"Steve," says Mari. "I think you're onto something big. I have an idea. Instead of bikers, I'll show my Goth fans riding horses over the steppes of Asia, like Genghis Khan, and into Japan."

"We've tried, but Japan stopped Genghis several times."

"But that will at least make for great battle scenes."

"Link them to samurai wars."

We sit back, imagining how to create a Virtual Japantown that links Emi's coplay designs to the evolution of Japanese fashion from the Yayoi era to Harajuku today. That is a lot of ground to cover, but we can do it online if Yumi offers open fashion contests.

"If you guys pull it off," says Steve. "Mayor Tiffany and I will host a citywide celebration of Virtual Japantown to welcome visitors from around the world to our "Diaspora" collections. You'll never have to struggle financially again, but we cannot promise any city funding to get City promotional support."

We thank Steve profusely. No wonder he is the world's first Black unicorn CEO. He thinks outside the box and is nice to boot.

"You know," says Steve. "When I sat in Army bunkers in Iraq, I had a lot of time to think about my future and the future of the world. Do I want to keep fighting and killing people who I don't hate or do I want to do something useful with my life? Virtual Fillmore was cool since I could revive our "Harlem of the West," but it felt too small and cut off from the Black diaspora and our human evolution and diaspora. If I could somehow link all peoples and cultures around the world in an interesting way to show how we are all one big family, I would be happy for the rest of my life. Perhaps we would have fewer wars. Virtual Fillmore became my personal mission and key to global understanding. Now, Virtual Japantown can join me in reaching out to the world. During the 1950s evictions, my parents repeatedly told me, Fillmore and Japantown are "joined at the hip" like me, socially, culturally, economically and politically. I'm the bicultural, biracial result of that convergence. Together, we can help both communities reconnect with the rest of the world."

"And your Black and Japanese heritage," I say.

"Yes, my bicultural yin and yang."

Steve pulls up his sleeve and shows his tattoo of two dragons, one Black and one Japanese, swirling in a tight circle chasing each other's tails.

"This is who I am -- my father and my mother linked in a tight circle of life – my yin and yang. My mission is to reconnect them with the coolest music, fashion and dancing in the heart of SF."

13

BIG BAND BLUES

My sisters, Yumi's Cal buddies and I launch Virtual Japantown quickly, thanks to help from Steve's amazing coders. Within days, they link our model of Japantown in 1945 to Virtual Fillmore, which is filled with sailors and their girlfriends celebrating our victories over Germany and Japan, seated in their shiny Fords and Chryslers tootling down the streets. Virtual Fillmore is hopping with big bands and blues singers in crowded nightclubs overflowing into the streets. Steve turns up the volume of his Ella Fitzgerald avatar singing New Orleans Blues. Everyone is happy and cheerful, hugging and partying into the night, while Japanese families returning from the desert concentration camps look lost and forlorn, like the Joad families escaping the Dust Bowl. They wear threadbare coats to ward off the chilly wind and fog. Their faces are serious and strained. They step off buses carrying a few pieces of luggage, their only belongings, and stare at their former homes packed with Black families. Blues music blows and swirls down the streets and alleyways like fog barreling down the hills. Foghorns moan in the distance. Black families share food and shelter with our despondent Japanese returnees.

"We're hopping!" says Steve, showing his grandfather's nightclub with pride. "Bop City invited only the best blues bands from New Orleans, Chicago and New York City. It had parties every night of the week for sailors on leave and returning to civilian life. I wish I had been there, but I wasn't born till the 1970s. I missed the good times before the City flattened the Fillmore. Man, we lost a national treasure. If this were Japan, the Moe would be a major tourist destination. Our blues boys would be honored as national treasures and their songs and outfits preserved in museums, but this is America. We destroy Black culture and thriving communities like

the Moe. We toss people away like used tissue paper."

Mari, Yumi and I are surprised by Steve's candidness since he always talks about the present and future with such optimism and hope. Although he dedicated Virtual Fillmore to his grandfather and father, he rarely talks about the past. His silence is deafening, like my grandfather's silence about the camps.

"How does the Moe's past inform our future?" asks Yumi. "What can we learn from Virtual Fillmore?"

"Ask everyone and listen carefully," says Steve. "It's not rocket science, just common sense, but most politicians, developers and community leaders get all caught up in their egos and grandiose plans then steamroll us little folks without asking for permission. It happened in the 1950s; it's happening again. They're ignoring us family businesses, kids and little old ladies who know the truth about the Fillmore and Japantown. I advise the mayor, but I'm just a bystander without financial and legal power. As a small business, I just want the truth, the whole truth and nothing but the truth, not just empty slogans from politicians trying to get elected."

"Even Mayor Tiffany?"

"Even her. She could lose re-election this November so she's making promises that she might not be able to fulfill. Meanwhile, decisions are being made behind closed doors."

"You're not party to them even as her advisor?"

"No, many City decisions are backdoor deals only open to elite developers and campaign backers. Total confidentiality."

"The old boy's club."

"Exactly."

"How do we involve Fillmore and Japantown without causing a scene?" asks Mari.

"Do something that works. Let's host Reimagine workshops with free food."

"Good for families, but what about young people?"

"Festivals, street fairs and performances at the Peace Plaza, especially this fall and winter."

"Nobody will come in the cold."

"That's why we go online. With Virtual Japantown, people can visit anytime, even during the dead of winter, and spend as much time and money as they want. We'll be open 24x7. Virtual Fillmore will promote you so visitors can find your shops."

"I love it!" says Yumi. "Free fans and foot traffic."

"But you need to show cool stuff since you'll be competing with my jazz, blues, rap and hip-hop events for eyeballs and shoppers."

"That's unfair," I say. "You guys dominate entertainment."

"We'll teach you. Can Japanese jump?"

Steve laughs, slapping my back. Talk about reversals; Blacks teaching Japanese about business, but Steve is the master."

"Guys," says Steve. "Don't get all uptight and serious. Hang loose and have fun like your taiko drummers and Nihonmachi Street Fair bands. We're not living in the 1930s. Mayor Tiffany and I want to see Japantown Live during your Peace Plaza construction or, better, Japantown Jives."

Steve ramps up Virtual Fillmore to get the ball rolling. Soon, his nightclubs blare with jazz, blues and R&D, attracting millions of online visitors. He builds a virtual garden walkway to Japantown. People check us out online, but we have little to show. "Under Construction" signs are posted everywhere.

"Girlz, our work is cut out for us," says Mari. "We've got to move much faster. Any ideas?"

My sisters and I mull over ideas about our virtual band when Emi jumps up to sketch ideas on the whiteboard.

"Noh-Noh Girlz can wear Noh masks."

"Why Noh masks?" I ask.

"We cosplayers are shy. We don't want people to make fun of us, which is why we wear masks and dress up in cosplay – to reinvent themselves as princesses, lords, captains and superwomen."

"And Goth conquerors!" says Mari. "My biker bros and girlz will want hard metal rock music, not saccharine J-Pop tunes. We need something hot and stunning, not just more of the 1980s and 1990s -- something downhome SF today."

"What's that?" asks Yumi.

"Something gritty, cutting-edge, and bold to fit our troubles times. Something useful that addresses pandemics, homelessness, hard drugs, robberies, car break-ins, anti-Asian attacks, filthy streets, loneliness and urban exodus."

"Is that all?" says Emi. "We're not running for office."

"And we're not running away. We're running toward the future."

"Sounds like a dystopia to me," says Yumi.

"Perfect! Let's open with Dante's Inferno and move through Purgatory toward our Paradise. We'll take everyone on a wild musical ride through Purgatory with our Noh-Noh Girlz rock band as our Virgil guide."

"You sound like a lit major to me," I say.

"Aren't we all dreamers with fantasylands?"

"Talking about fantasyland, let's reach out to my women biker friends," says Mari. "They can guide visitors through the West to see awesome national forests, deserts, lakes and oceans. The future of Virtual Japantown is much bigger than a few blocks in SF. It is the world."

"Did you inhale?" asks Yumi.

"Just inspired by Steve. He says we can link virtually to Japan and Brazil then the world. We need to do something big and stunning like he does with Virtual Fillmore."

"If he says it's possible, let's do it," says Emi. "All for one, one for all! Noh-Noh Girlz will reinvent Japantown. This will be our big blast and gift to the world!"

"But first we need to involve mom," says Mari. "We need her blessings, not more kimonos."

Oops, a minor detail...

14

VIRTUAL MOM

Mari takes the lead for Virtual Japantown. Our Noh-Noh Girlz rock band is a wonderful idea but we have never created a virtual band from scratch. How do we do it since none of us are musicians? All we have is mom's Kimono Minds shop from the 1990s, our tiny, unknown collections of Goth and cosplay outfits, and lots of imagination and frustrations. Except for mom, we are total nobodies in the fashion and music worlds so Steve thinks we should leverage Kimono Minds, which is too retro for us.

"Guys," says Steve. "Your mom is right. Build your future onto the past, like I did with Virtual Fillmore. Start with what you have. You can always add to it. I didn't make up the Fillmore jazz scene from scratch. I just showed it with VR. You can do the same so you don't have to reinvent the wheel. Use your imagination. If VR lets you create anything you can imagine, why do the same old stuff? Why not reimagine Japantown into something fresh, new and compelling?"

"Like what?" asks Mari.

"Goth bikers riding Heian horses or anything that will grab attention. Let me show you."

Steve drops a few bikers in Goth leathers onto virtual motorcycles and speaks into AI software. The bikers transform into Heian princesses and princes riding awesome stallions, which turn back into motorcycles.

"Holy shit," says Mari. "How did you do that? That's my dream come true. Time travel shapeshifters!"

"AI works like magic. Just speak slowly and clearly into the mic."

Like a kid, Mari scans in mom's best kimonos and drops

them onto Heian princesses seated on beautiful black stallions. She commands the horses to gallop past temples along the Kamo Riverand they flow like gazelles with a palace in the background.

"Amazing!" says Mari.

"That's just the beginning," says Steve. "If you move fast, you can create Heian Kyoto for your mom by Cherry Blossom Festival. Make sure to add her into the scenes."

"How?"

"As a beautiful princess with long black flowing hair wearing a gorgeous gown, seated next to her Genji lover, just like the "Tale of Genji.""

"Get out of here! That's unreal."

"The more amazing, the better. Mayor Tiffany and I want you to blow away everyone with Virtual Japantown. Show the world what's possible using voice AI and what they're missing by not going virtual."

Yumi scans in mom's face, which pops up onto a Heian princess wearing her best kimono designs, seated in a palace overlooking a sea of cherry blossom trees. She looks so gorgeous that our mouths drop open with awe.

"She looks like a real Heian princess," says Mari. "Now I understand why she loves the Heian period. Dad was her prince charming from the Osaka area. I love it!"

"You'll be able to show anything during the Heian period and before or even into the future."

"Like shamans and sorceresses too?"

"Anything you want. VR is your magic carpet so enjoy the ride."

My sisters go crazy directing Steve's team so our Virtual Heian Kyoto is perfect. In our Virtual Japantown shop, we link her traditional and modern, multicultural kimonos with our Goth and cosplay designs. Emi dolls up Heian princesses with dayglo cosplay outfits, while Mari creates princesses, warriors and even priests wearing Goth-like Heian military outfits. As a coup de grace, Mari drops mom as a virtual Heian princess into a palace court surrounded by beautiful princesses dressed in kimono patterns from her collection. With help from Steve's designers, we create the world's first Virtual Heian Kyoto within days.

For her Cherry Blossom Festival collection, we surprise mom. Steve puts a VR headset onto her head then switches on the scene. Mom jumps, her mouth dropping open. She looks around the scene like a kid, trying to touch the virtual horses and kimonos, shaking her head with disbelief.

"Kyoto!" she exclaims. "My kimonos! My home! You've created my dream!"

Mom plays with her virtual princesses and horses, trying all sorts of mini-dramas, from flirting to dancing and horse races, with the help of an AI advisor. She keeps shaking her head with disbelief. Finally, after twenty minutes, she takes off her headset, exhausted, her chest convulsing and her cheeks moist with tears.

"This is how we relive the past, reinvent the present and create the future in Virtual Fillmore," says Steve. "They are all one space/time Multiverse. Our new reality is pure imagination and virtual magic. You can create any fantasy. It's a dream machine and a time machine."

Mom gives Steve a big hug and rocks back and forth with him like they are dancing. Steve grins like our Persian cat.

"We will reinvent Japantown," he says "We will reinvent Virtual Fillmore. We will reinvent San Francisco and the Bay Area, one virtual block at a time."

15

NOH-NOH GIRLZ

Virtual Heian Kyoto was the easy part. We studied photos and paintings of Kyoto to create virtual versions with Steve's team. It was fun but mostly detailed historical research. Inventing our Noh-Noh Girlz rock band for Virtual Japantown will be much harder since it will require total creativity and imagination. Not only do we have to create original avatars, animate them and lip-synch their mouths with AI, we have to write stories, jokes, and lyrics, produce the music, and create new costumes – all from scratch – like Pixar does with hundreds of brilliant artists. How can we do it faster, cheaper and better with AI? Designing the outfits will be simple since Mari and Emi have dozens of collections. Learning AI prompts to create images is a matter of trial and error; anybody can do it. But creating a badass rock band with awesome dancing and songs will be like climbing Everest. Only a few bands have succeeded online like Gangnam Style. We can create simple images, tunes and stories like other J-Pop artists but how can we be truly original and popular?

"What do we do, girlz?" asks Mari. "We've got the outfits, but no music or stories. Any ideas?"

"Let's ask our friends," says Emi. "I can invite my cosplay girlz to a brainstorming party."

"I'll invite some bikers."

"Make sure they're not jerks. We don't want the police to shut us down again."

"OK, only medium-rare tough."

We laugh but you can see fear in the eyes of Emi and Yumi who frankly dislike Mari's biker friends, many who look and act like predators around women.

"Can you tell them just to look and not touch, Mari?" asks Yumi. "I don't want people to get the wrong idea."

"No problem," replies Mari. "I'll make sure my tough girlz keep the guys away. They'll be my cops."

For our brainstorming session, we send out hundreds of invitations. Dozens sign up, including Emi's cosplay friends, Mari's biker buddies, and Yumi's Cal bros. I set up whiteboards and tables of notepads, markers, stickers and food, which attract the bikers who pile in wearing heavy boots and leather jackets. Our studio soon looks like a Hell's Angel party. Emi's cosplay friends tiptoe in quietly, dressed in their best J-Pop costumes, and cluster in the corner to avoid the bikers. Yumi's bros discuss coding.

"Boyz and girlz," I say, serving as moderator. "Thanks for coming. Today, we're reinventing Japantown to attract new visitors so we can help merchants stay afloat. To do something fresh and original, my sisters want to create an online rock band called Noh-Noh Girlz and need your help."

"What does Noh-Noh mean?" asks a biker.

"It's a play on words combining Noh masks for anonymity, like Carnaval masks, with the infamous loyalty questions asked by the Army in the Japanese American WW2 concentration camps. People who answered no-no were thrown into tougher prison camps and deported to Japan."

"Sounds like the greetings we always get. Why that name?"

"My sisters want to create a contrarian AI rock band that can break from tradition, reimagine Japantown's future for everyone, not just Asian Americans, and sing anything they want without fear of criticism, shaming, physical attacks and job firing."

"So we're supposed to be DJs?"

"Bold spinmeisters who create new ideas, music, and dancing that would interest your friends. We have whiteboards so you can jot down ideas. Give titles to your designs. You'll all get free teeshirts. The best creators win free outfits, either Goth or cosplay."

"Any sales commissions or royalties?"

"Definitely, 10% of gross income from your designs."

Everyone perks up, suddenly looking interested for a change, with some already jotting ideas onto their pads. Without much prompting, everyone quickly settles down to jotting and sketching ideas so we get a ton of design ideas fast. Within three hours, our

whiteboards and sketchpads are filled with ideas so we ask the participants to put stars onto the best ones. We break for lunch and sit around chatting with the attendees. My sisters and I pick the most popular designs. After lunch, I announce the winners for Virtual Japantown:

- E-bike Village
- Green Transgender Life
- Fat and Happy (for cosplayers)
- Life, Liberty and the Pursuit of Akitas
- Unagi Haven
- Sushi Paradiso
- Zen Weed
- Shadow Puppets (Bunraku, Noh, Kyogen and Rakugo!)
- Cinco de Ramen
- Ramaytusch Ohlone Onsen (geothermal spa)

"It looks like we've definitely captured the essence of the City and its passions," I say. "Any lyrics or musical styles? We'll give you half an hour to write up lyrics and ditties."

The participants jot down ideas and submit them to us. My sisters and I go over the lyrics and nod.

"I think we've got some potential winners here," says Mari. "Let's try them with GenAI platforms to see which ones work best."

Yumi and Steve take all the sketches and create cartoon-like VR avatars that can talk, sing and dance using AI. Within days, their teams spin up rough versions of their singing avatars. Overnight, our Virtual Japantown is hopping with singers and dancers. We are absolutely stoked. Without spending much, we have created Virtual Japantown overnight and populated it with authentic scenes and avatars designed by the winning teams. The best thing is that the participants get paid for their design sales. We believe in sharing the wealth like mom does.

"We're hopping!" says Steve. "It took me years of hard work and lots of fundraising to build Virtual Fillmore. You guys built Virtual Japantown overnight for free. You're the future Metaverse that pundits and I have been dreaming about."

"How do you make money?" asks Mari.

"Virtual Fillmore sells events, products and services on our platform. I'll just hook Virtual Japantown into our platform and

you're good to go."

My sisters and I look at each other, pleased, and give Steve our traditional Morioka family hug. We look ridiculous, fawning over Steve and punching our fists into the air like Warriors, Giants and 49er fans when we win the championship.

"We rock!" yells Mari. "Virtual Japantown will show the world! Now the real fun begins."

Mari pulls up videos of her Goth customers who play in rock bands, all dressed in classy punk leathers of all different colors.

"Not just Black – we'll let Steve handle that color – but all colors of the rainbow, like the City. We'll sell Goth, kimonos and cosplay fashions of all colors for people around the world."

Mari sounds like she has been smoking weed.

"Using regenerative textiles, like weed, and new biomaterials grown in our hanging regenerative gardens."

Of course, weed, to include her buddies.

"Hanging gardens?" asks Yumi. "Where?"

"On the south-facing wall of our shop, later Geary Boulevard which has a huge Japan Center south wall. Now it's a total waste of space. We can show a VR hanging garden then lease the virtual wall rights to people growing real hanging gardens."

"Wow, that's off the wall," says Steve, smirking. "I never would have thought of it."

"You recreated the Fillmore's past with Virtual Fillmore. We want to reinvent Japantown with cool new venues, but you've set a high bar. Why do you think I take weed pills? Faster, cheaper and more creative than workshops."

"Cool regenerative fashions are just the beginning. Next, we need to launch the Noh-Noh Girlz virtual rock band."

"How will we do that?"

"Easy. Steve offers his avatars, which we clothe in our Goth, kimono and cosplay designs, then animate them so they can sing and dance. That's where our lyrics and short stories coming alive with VR avatars. Creators can sing and edit them on the fly with AI to create any style – hip-hop, rap, country, blues, J-Pop, K-Pop, anything they can imagine."

"I must say," says Yumi. "Mari's weed habit is infectious. She is creating more new ideas brainstorming on weed than we have come up with community and Cal workshops for weeks or even

using AI for hours. Maybe we should offer creative weed workshops."

"You guys are too uptight and serious," says Mari. "You need to chill like my boyz and girlz. It works for me. I'll call our super creators."

Mari calls her top bikers who arrive on big bikes, dressed to kill in their coolest rainbow leathers, and pile into our little studio. With Yumi's help, they talk into AI platforms and create all sorts of music and lyrics for our virtual Noh-Noh Girlz band. Within hours, Emi's cosplay friends have created cosplay avatars of all types. Yumi lip-synchs the songs and animates the avatars so they sing and dance on our virtual Peace Plaza stage. We create it within hours without any money, stage permissions, trucks and sound system set-ups.

"This is the new Japantown!" shouts Mari, leading her biker friends dressed in rainbow leathers around our virtual Peace Plaza to the rhythms of Obon rock tunes. Emi adds her cosplay avatars and Yumi makes sure to include mom's multicultural kimonos. Soon our virtual plaza is filled with our Noh Noh Girlz of all races and ages dressed in virtual outfits, dancing and singing "We are virtually united!"

We invite mom to our launch party and her mouth drops open.

"I thought you were going to help me revive Kimono Minds," she says, frowning. "Where are my kimonos?"

"Here they are, mom," says Mari opening a slide shoji screen on the Peace Plaza stage to reveal mom's kimonos worn by virtual avatars of her girlfriends – Japanese, Chinese, Latino, Black, Jewish, Arabic, and European.

"We're bringing you and your friends into the 21st century," says Yumi. "This is just the beginning. Wait until you see what our fans create."

Our mom nods, sniffing with appreciation. We give her a big family hug. A family that designs together stays together.

16

HACKERDOM

Our midsummer night's dream lasts only a fortnite. Before we even launch our carefully rendered Virtual Japantown, hackers strike. Like locusts descending onto crops, they ravage our Noh Noh Girlz rock band and deface their outfits, turning them into zombies and ghouls. Yumi immediately takes them down, but the hackers add their own zombies before Steve's cybersecurity team can act. Within hours, our magical Virtual Japantown turns into a "midsummer's nightmare," as Mayor Tiffany puts it. She has been promoting the hell out of Virtual Japantown so it is a major embarrassment for the City.

"How do we stop the damage?" asks Yumi at our huddle with Steve.

"My team is setting up stronger firewalls that hackers can't penetrate easily," he replies. "I'll make it more robust than Virtual Fillmore, which is also facing tougher hacks. We know their tricks but they keep adding new ones."

"What if they leapfrog us?" asks Yumi, who is worried since her Cal cybersecurity professors are studying us under a microscope.

"Don't worry. We can handle most of the attacks. Mayor Tiffany is offering the City's cybersecurity team as backup since they are seasoned in ransomware."

"That's that?"

"Hackers demand huge amounts of ransom money to bring VR sites back up. It's a growing problem in cities today."

"Will it work?"

"We're developing new AI system to outwit the hackers."

"What if they use advanced AI systems?"

"Like China and Russia? We're monitoring them and trying to keep one step ahead."

Our mother sits back, shaking her head.

"I don't like VR," she moans. "I just want to go back to the old days when we knew our customers and met them face-to-face instead of chasing AI criminals."

"Unfortunately," says Steve. "There's no going back. We're living online in 2D and going 3D and even 4D in the future."

"4D? What's that?"

"Space/time travel using AI and advanced consciousness technologies."

"My head hurts. I just want traditional kimonos and Kyoto, not this Star Wars future."

"Mom," says Yumi. "Don't worry. We'll protect you. We have the smartest guys in the world with Mayor Tiffany, Steve and their VR cybersecurity team."

"Ok, just be nice to my customers. I don't want them to run away forever."

"They can't. There is no more space/time separation in AI virtual worlds. Your Heian Kyoto is inseparably linked with Virtual Japantown and all possible futures."

"Like reincarnation?"

"Better than that, we'll be forever young…"

Our mom smiles like a mischievous child.

"So we can flirt in Heian Kyoto to find our prince charming?"

"All you want."

"Hontoo! (really!). You've just given me a great marketing idea."

17

THE WILD EAST-WEST

Promising mom is easy; actually keeping out hackers is the hard part, like old San Francisco when it was filled with shysters, grifters, loan sharks, corrupt officials and crooks. Our Virtual Japantown is quickly becoming the Wild East-West, the Barbary Japantown that my father studied for decades to produce our Bunraku plays. We are totally open and vulnerable so we attract slackers, hackers, robbers and ransom artists of all colors and nationalities. The attacks, defacements, and avatar crooks are off the charts in terms of their uniqueness and creativity. Even Yumi's seasoned Cal computer science professors have never seen such a variety of innovative virtual attacks. To our chagrin, Virtual Japantown has become a juicy testbed for hackers.

"We're the UN of Virtual Hackers," says Yumi, clicking on the latest hack report. "My professors are jumping for joy since we're so data rich. We're getting two hundred attacks an hour. Steve's team only stops 95% so the rest are wreaking havoc."

"I thought Steve and Mayor Tiffany had cybersecurity nailed," I say. "What happened?"

"Noh-Noh Girlz is the first multicultural virtual girlz rock band so we're attracting more traffic than usual. We've shot to the top of the Virtual Billboard 100 in one week and surpassed one billion viewers. We've beaten Gangnam Style, which took a month."

"Bravo," says Mari. "But that super sucks; a billion viewers jeering the hackers -- like novice bikers who crash and burn their new machines – a definite no-no. We've got to stop the hacks fast or we're history."

We sit around, grasping for ideas when Yumi jumps up.

"I got it!" she says. "Let's ask Steve to build Noh-Noh Boyz

guards to protect our Noh-Noh Girlz!"

"Guards?" asks Emi. "How?"

"We can create AI avatars to stop virtual attacks, like Superman. That would appeal to male egos."

"Ego stroking works. Do we have systems for that?"

"I know martial arts masters who can work with Steve's cybersecurity team. They can build virtual guards to protect Noh-Noh Girlz and Virtual Japantown visitors."

"Sounds like a game to me."

"Everything is gaming today. Mayor Tiffany and Steve are expert gamers so they can host it to protect Virtual Japantown and other cultural districts. It could be a citywide VR cybersecurity game to protect our assets and communities."

"That's brilliant," says Yumi. "My Cal buddies will love it since they're gamers, as well as Mayor Tiffany's Stanford friends. We can even create a Cal vs. Stanford VR cybersecurity challenge to see which school creates the best solutions.

"Oh, my God," says Mari. "We're turning everything into a game, but what at about our fashions? Don't forget them."

"Let's turn them into entertainment, whether fashion, TV game shows, gaming and e-sports. We need to stay ahead of the curve. If we're going to revitalize Japantown, we need to gamify it since most young people are J-Pop fans and gamers. Our secret weapon: Mayor Tiffany and Steve are top gamers who lived in Japantown as kids. Mayor Tiffany is frustrated with politics so Steve says she wants to have fun, not just argue with politicians and critics all day. Why not invite her to lead the coolest virtual game around: Virtual Japantown and Virtual Fillmore."

"Are you toking weed?"

"Just during final exams but this is the biggest test I'll ever face. Top grades are good but the real test is our family finances. Do we want to survive or not?"

I agree with Yumi; we have to buckle down for a long, hard ride since we have little savings and face an incoming stream of hackers. We need to generate income ASAP so it's Virtual Japantown or bust, or Steve kindly reminds us: Go for Broke or go broke! Can we pull it off to avoid going down in flames like most artists and virtual startups?

Now I understand what dad meant by Barbary Japantown in

the late 1800s. The Gold Rush attracted miners and merchants who attracted crooks from around the world. Japantown rose in the 1890s, just in time for the Barbary Coast when the City was filled with idlers, grifters and ruffians seeking the Next New Thing. Our Issei great-great grandparents lived through that rocky anti-Asian era since they were targets for every politician and crook in town. History repeats itself. Virtual Japantown is the new Barbary Japantown under attack. Will we survive like the Issei or crumple? We need help – and fast.

Yumi and her Cal team scramble to work with Steve's Virtual Fillmore team to create virtual guards to protect her Noh-Noh Girlz rock band, whose members are decked out in regenerative J-Pop outfits. Emi invites her cosplay friends who suggest fashion ideas. Soon, Virtual Japantown is hopping with fashionistas and their AI avatars.

"We are rocking and rolling!" says Mari, displaying her army of Goth cosplay avatars dressed in a rainbow of color leather jackets and boots. They look like the Pride parade on bikes.

Of course, the Hell's Angels show up to avoid missing out on the party. Japantown merchants are terrified, afraid that their foot traffic will die. Steve and I have to reassure them that we are providing Noh-Noh Boyz online and City cops to prevent real-world crimes. Fortunately, we are mostly online but we hold our breaths anyway, praying that nothing happens in Japantown.

Unfortunately, visitors show up in Japantown, greeted by the Hell's Angels. Many visitors immediately leave, terrified by the snarling bikes as the Angels gun their engines. Steve runs out to the bikers and asks them to move on. They laugh and move a bit – across the street – then race up and down Geary Boulevard past the Peace Plaza, gunning their engines to make sure everyone hears. Of course, the media shows up, which only encourages the bikers to gun their engines louder.

Meanwhile, Mari's Goth fans and Emi's cosplayer fans show up in full regalia. Soon, Japantown is filled with Goth and cosplay fashionists strutting their latest designs. Post Street looks like a Cherry Blossom Parade, with Goth and cosplayers of all colors and genders milling about, with the Hell's Angels shouting and arguing with the police who tell them to move on.

Steve tries to break up the arguments, but the bikers ignore

him. By noon, Japantown looks like a huge circus of bikers, Goths, cosplayers, freaks and the homeless yelling and screaming at each other. Our launch goes viral, with tens of millions of viewers viewing the mayhem in the streets on television and blogger sites. We are globally infamous; the media calls us the "J-Town Shitshow."

So much for our "Wild East-West" world; the City's tourism board calls it "Overtourism 1.0" and politely asks us to control our fans.

18

A MIDSUMMER NIGHTMARE

To recover from "Overtourism 1.0," Steve, my sisters and I hunker down to save Virtual Japantown from hackers and our real Japantown from wild bikers and even wilder fashionistas. Many begin wearing masks to conceal their identity from police cameras. Inspired by the Noh masks worn by our Noh-Noh Girlz band members, fashionistas wear Noh masks to make Japantown look like a Harajuku celebration of J-Pop celebrities in a Noh drama.

"We're succeeding but at what cost?" asks Yumi. "I can manage Virtual Japantown, but not the partygoers in Japantown."

"The joys of success!" says Steve. "Mayor Tiffany loves the over-tourism since Japanese and American motorcycle makers are throwing themselves at her to sponsor Virtual Japantown and real Japantown events. Ka-ching!"

"But the Japantown merchants? They're up in arms. We can't afford to alienate them."

"I'm planning a big powwow with them this week to discuss over-tourism solutions," says Steve. "We're studying Venice, Rome, Kyoto and Paris to learn how they deal with it."

"What are you learning?" asks Mari.

"First, divert tourists to other less-visited cities and regions."

"But we only have one Japantown."

"We're pointing people to the Haight, Mission and Dogpatch since they need visitors."

"That won't stop people from visiting Japantown."

"Mayor Tiffany needs to help all districts, not just Japantown so we're planning a "Share the Pie" strategy to revitalize all of our 31 cultural districts, based on the Virtual Fillmore model and, now,

Virtual Japantown. The difference is that Japantown is the leader since it's using AI avatars differently than the Moe."

"How?"

"J-Pop folks move fast like day traders. Virtual Fillmore folks are aging baby boomers who prefer conservative growth stocks.

"What does that mean for us?"

"We need to live in real time 24x7 and manage their expectations to avoid chaos."

"Stay all day online?"

"I'm afraid so, plus Mayor Tiffany needs to share the wealth with all cultural districts to get re-elected."

"So Virtual Japantown becomes the first real-time AI commerce platform in the City?"

"Like Wall Street trading, but 24x7 year round. The city controller is talking with the SEC, which is concerned about fraud, scams and money laundering."

"Fraud? Virtual Japantown visitors are cheating people?"

"They're preying on the rush of visitors and embedding malware to steal their identity and credit card numbers."

"Holy shit," says Mari. "We're screwed. The SEC will shut us down."

"Not yet," says Steve. "Mayor Tiffany and I are working closely with their fraud teams to beef up our cybersecurity. We'll soon have the toughest security walls in the world."

My sisters and I sit back, stunned. We did not realize our innocent little fashion site would get embroiled so fast into cyber scams and money laundering. Things move so fast today that we are not prepared for everything.

"Should we shut down Virtual Japantown until the crisis blows over?" I ask.

"Keep it open," says Steve. "My team will beef up security and funnel it through an SEC-approved filter. We want to see and control whoever is visiting our sites. The feds have even given our project a cute name: Overtourism 2.0. We're letting the City's tourism board manage it to not tip off scammers. We want people to visit Virtual Japantown and the City, not scare them off since we need the tourist dollars."

"Holy shit," says Yumi. "This is getting bigger than my Cal computer professors thought."

"Just keep it mum for now at Cal. We need to pretend that the SEC and FBI are not involved and that Virtual Japantown is just another City tourism site."

"The FBI? Why are they involved?" asks Emi, looking worried.

"In case they need to prosecute," says Steve. "We've had a few illegal breaches."

"Like what?"

"They can't say much. Let's just say it's big and global."

My sisters look at each other, their faces turning pale. Mari moans.

"My tiny Goth business is finished," she says. "Just when we were starting to get some traction."

"Don't worry. Mayor Tiffany and I have your backs covered. Just keep promoting Virtual Japantown. You'll be attracting visitors to the City and branding it as the #1 virtual city."

So here we are. Barely into the summer holidays and our little Virtual Japantown romp has turned into a midsummer's nightmare, thanks to over-tourism. As my father always warned me: Watch out what you wish for.

19

CHAOS CITY

Life is like a football; it usually bounces the wrong way. With Virtual Japantown, we are learning that nothing is predictable. We have our neat game plans laid out precisely like dinner settings, but newcomers keep upsetting everything. Our shopkeepers love the money but not the crush of tourists. On weekends, you cannot even find parking or restaurant seats. We thought tourists would save Japantown but overtourism is crushing it like Venice and other popular destinations. We are drowning in tourists. In August, both virtual and real Japantown became victim to Overtourism 3.0. Japantown is now called Chaos City, with bikers attending Mari's Goth leather shows and hackers trying to take us down. Pundits say we are a screaming success and a total shitshow. Mayor Tiffany's cybersecurity teams are struggling to stop hackers from taking over Virtual Japantown, Virtual Fillmore, Virtual Haight and Virtual Mission and bikers from taking over our real-world neighborhoods. Our lovely city is drowning in hackers and bikers.

 The media crows with delight, mocking our foibles with blaring headlines: "Chaos City on Steroids!," "AI Cops and Robbers!" and "Virtual Hacker Haven!" Mayor Tiffany and Steve try to stop the hackers but SF has become a gigantic Whackamole game. We shut down hackers and more pop up. The attackers turn Mari's Goth avatars into zombies walking around with ghastly Noh masks.

 "No, no, no, no!" Mari yells. "Not my collection! Not my life's work!"

 "Chill, Mari," says Steve. "My team will get it under control."

 "Do it fast or my name will go down as the biggest meltdown in biker history!"

 Mari hugs Emi for dear life as we watch online critics

mocking her. She is now radioactive among Goth designers who avoid Virtual Japantown and go elsewhere. Considered a "virtual basket case," her online shop goes silent.

Mari flops onto the couch and breaks down crying.

"Why does this have to happen to me? Why now? I just planned a big Goth party for Halloween and now nobody will come. I'm a total laughingstock."

I go over to Mari and give her a big hug.

"Look, it won't last forever," I say. "Mayor Tiffany and Steve will get the hackers under control."

"They'd better or it's sayonara to our dreams."

Mari wipes her nose, bawling like a child. I have never seen her cry this much. Usually, she is a butch woman who does not take shit from anyone, but these hacker attacks have undone her, as it is doing with all of us. The media blares the latest attacks on Virtual Japantown, which has become a pariah for online and real-world visitors. Overnight, we are becoming a ghost town with nobody daring to enter our virtual and real shops.

Steve drops by to discuss Mayor Tiffany's game plan.

"We're going DEFCON 3," he says. "We're pulling out all the stops and building a cybersecurity wall to top all walls."

"How are you going to do that?" I ask. "Even your best teams aren't cutting it now. As soon as they add security, the hackers find loopholes and swarm Virtual Japantown."

"Only for a while. We will figure out hack-proof systems."

"How?"

"Just watch. We will reimagine Japantown."

"Virtually?"

"Virtually and for real. We'll turn Chaos City into one of the coolest, most visionary communities in the world. Just give my teams time, but you guys also need to up your game by beefing up Noh-Noh Girlz. Nobody will return if you're not cool."

"Like what?"

"That's your challenge. Show the world something new, fresh and different from anything you've done before online and offline. You need to totally reimagine the future of Japantown."

"Easier said than done."

"If you want a future, it is Go for Broke or go broke!"

Part 3

Reimagining the Future

20

LOST IN TRANSITION

How do we reinvent ourselves? How do we survive financially and stay in Japantown? All of our shopkeeper friends are aging and worried about our uncertain future so they are thinking of shutting down and retiring. Will we be the last traditional family business standing? My sisters and I have tried everything, including Virtual Japantown, but it is a total shitshow. We spend more time dealing with hackers and cybersecurity than designing fashions. We need to totally rethink our goals. In the past, it was easy; we just did more of the same, like mom's kimonos and dad's Bunraku puppet shows, adding a few tweaks to freshen them up for new audiences and promoting like hell online. It worked; my parents survived and set themselves apart, thanks to our "Go for Broke!" attitude. We kids inherited their banzai mindset but it is not working anymore. The world is changing way too fast; AI is accelerating it. Tastes are changing; baby boomers are retiring; young people are happy with the corporate invasion of manga, anime, and cosplay. We like J-Pop, which is revitalizing Japantown, but it is imported, not created by local artists. We are just mimicking J-Pop fashions like SF fashion designers are doing with Eurocentric designs. Even Emi feels guilty about copying the Harajuku Look. We need a clean break. We need something of our own, a uniquely SF Look. We need to transcend our tired past, which no longer appeals to today's multicultural and transgender people, and design the future. We are searching for our future but have not found it yet. We need a massive transformation.

How can we create what we are becoming as a community? How can we reimagine mom's studio and Japantown for the future? How do we launch our ventures? It definitely is not by singing J-Pop songs, copying J-Pop cosplay fashions and adding pretty murals about the past. We need to reimagine, own and create a future that is

fresh, visionary and uniquely ours. Where is that spark of imagination? Where is our future? Where is our "Go for Broke?" drive to escape our bunker mentality and concentration camp mindset of the past?

My sisters and I hunker down in our tiny Kimono Minds shop, surrounded by aging kimonos, wondering what we can do to reverse the tide of bad news. We are desperate for major changes since our savings are evaporating. I am watching our bank account speeding to zero. If we do not turn around soon, our mighty Morioka family goes bankrupt. We are out of business – kaput. We will have to sell our shop and leave town, our parents' efforts gone forever. With City prices escalating, it's one-way trip. We will be lost in some distant suburban mall and become culturally irrelevant. For us designers and inventors, that is a fate worse than death.

"OK, guys," I say. "What do we do now? Virtual Japantown is a bust. Steve says the City is spending so much money and time trying to save our ass that supervisors are upset at the favoritism shown Japantown."

"But we're leading with Virtual Fillmore," says Yumi. "Virtual Japantown has introduced AI avatars and cosplayers."

"As well as hackers. The City needs more real-world tourists and artists, not online scumballs. The supervisors are pressing Mayor Tiffany and Steve to cut the City's exposure. Unless we figure out something that works, we're history. The City will move on."

"To what? The supervisors have no original ideas."

"To street festivals with music and food."

"More of the same. They're costly and only done once a month until the sponsorship money runs out. The streets are empty most of the time."

"What else can we do? Virtual Japantown attracts hackers; street festivals are costly. Are there any alternatives?"

We sit around sipping hemp tea, Mari's favorite elixir for dreaming up cool ideas. Emi doodles new cosplay figures of boyz and girlz prancing around like unicorns. Yumi toys with her AI avatars of Noh-Noh Girlz, getting them to boogie like street dancers. We are bored with our old ideas.

"What if we turn our Noh-Noh Girlz rock concerts into a regenerative fashion festival?" asks Emi.

"How?" asks Mari, perking up.

"Mayor Tiffany loves wearing her green hemp gown at city cultural events. It's her therapy from the City's budget blues. What if we propose a Regenerative Fashion Week to attract women, girlz and fashionistas, not just bikers and music goers? Maybe we could revive downtown, not just Japantown."

"How would it be organized?"

"Good question."

Emi sits back, doodling on her pad and coloring fashionista models in shades of green.

"I like St. Patrick's Day because everyone wears green, like environmentalists and climate activists. They love partying, celebrating their projects and having fun. People don't fight like bikers or copy each other like J-Pop cosplayers. They're more aware, less self-conscious, and liberated."

"Liberated?"

"Less worried like Asian Americans about what others think of them, less likely to copy others to fit in. They just want to have fun and celebrate, not worry about protecting their cultural legacy, which is why I always party at St. Paddy's Day. I can wear any green cosplay outfit I want and nobody makes fun of me."

"People in Japantown make fun of you?"

"All the time. I'm heavy so they avoid me. Asians prefer thin girlz who look like J-Pop singers. Why do you think I wear cosplay outfits around the City? Nobody makes fun of me. Instead, they compliment me and say I'm cool."

"So that's why you're into cosplay – to be complimented."

"And feel welcome, not mocked. A lot of us girlz feel that way. We hate people making fun of our weight. We're always expected to look thin and sexy like Britney and Rihanna. It gets old fast."

Emi drops her pencil, her eyes moist. Mari goes over to give her a hug.

"I know the feeling," says Mari. "People make fun of me too. They call me butch and bitch because I'm not all frilly like party girls. That's why I love my biker buddies; they treat me like one of the gang."

"And that's why I create beautiful AI avatars at Cal," says Yumi. "My buddies are all guys but they accept me as an equal, not put me down as a girl."

"So it's all about acceptance," I say. "About being accepted for who you are and not being laughed at."

My sisters turn to me, nodding.

"You finally get it," says Mari. "You're like so many clueless guys. You make fun of us. You ignore our complaints. You ignore our obstacles and wonder why we girlz rarely succeed. People laugh at us and never take us seriously. They think we're crazy, butch, angry women, or just nuts, but not serious designers. You're a robot bro surrounded by robot bros. You'll never understand how we girlz think or feel until you withhold judgment and look below the surface and see the world from our perspectives."

"I'm sorry if I've been clueless. I'm just not in your shoes. So that's why you created Noh-Noh Girlz -- to hide your no-no protests behind virtual Noh masks."

"To protect ourselves. I hope you understand how we girlz feel. We're no different than mom – short Asian American women in a tough, competitive world that doesn't care much for women artists and innovators. People say they love the arts, but they make fun of us. They think we are totally crazy. We're always the leftover kids never invited to teams and parties, but ditched to survive on our own. And you wonder why we stick around our shop and rarely venture out. Only mom understands us."

My sisters suddenly become silent, as if the huge cloud hanging over us has burst. That oppressive feeling, deepened from years of mockery and our depression after dad died, has fractured. For the first time in their lives, my sisters say what they truly feel.

"Guys, I mean girlz," I say. "I'm sorry I haven't been more attuned to your feelings. I'm just trying to help mom keep our shop open. I didn't realize how you felt."

"It's OK," says Mari. "You're a busy guy. We don't expect you to understand how us girlz feel. You'll find out soon enough. The world is not all nice and comfy like home. It can be pretty nasty at times. We live on the Barbary Coast. And you wonder why dad was always so fixated on Barbary Japantown for his Bunraku plays. He didn't want to be a doormat. He knew and saw where we came from and how hard it was for the Issei, Nisei and Sansei to survive, but they did -- Daruma style. Now it's our turn to bounce back, stand up and keep Japantown alive."

My sisters sit back, sprawled on our couch like rag dolls,

immersed in their thoughts. I give them big hugs. I feel bad. I have been so focused on robots, school and helping mom that I took their struggling art careers for granted, never realizing what they were experiencing and feeling. I never understood the deeper dramas behind their smiling masks. Dad always said I needed to dig deeper into the human psyche and society to become a truly great Bunraku artist and robotist. Without understanding the heart, one cannot see and feel reality to become a true artist or ethical scientist. One just sees facades and puppets, not real people struggling to survive and thrive.

My sisters get up to take a seventh inning stretch. It has been a long, difficult session but we are making progress. We are becoming unified as a family, even though we are splitting off from mom's kimono business and seeking our own paths. We want to pursue our dreams but know we need each other's support. Either we swim together or drown separately.

21

GO FOR BROKE!

One thing great about being Japanese American is that we have an awesome heritage to draw from, especially our kickass 442nd/100th Infantry Battalion from World War II who volunteered from concentration camps, knocked off Nazis and liberated a Dachau sub-camp. Tough badass guys! They knew fear but never let it stop them. My father always said the 442nd/100th were Yankee Samurai who hunkered down in firefights and battled their way to save the "Lost Texas Battalion" and the village of Bruyere on the way to Dachau. He said we need to think like the 442nd/100th since we are a shrinking minority without much political power and little economic power because we lost it all during WWII when it was stripped from us by the government, white farmers and cagey realtors.

But that's history. Today, our battle is financial survival – saving our shop and launching Mari's Goth designs, Emi's cosplay fashions, Yumi's AI avatar world, and my robots. We Moriokas are crazy; we dream big but have no money, just pure drive and teamwork. Our only option is to hunker down and dig our way out of poverty. Mayor Tiffany and Steve can help Virtual Japantown, but they cannot save our business. We have to figure it out on our own.

"It's Go-for-Broke time again," says Mari. "I wish dad was here to coach us. We have to remember how he and mom did it."

My sisters and I shake our heads with regret. We were young and restless so we ignored how they ran their businesses, complaining about helping out and instead going out to play with our friends. We knew nothing about small business, only that it is a ton of long hours, little money and constant worries over paying bills and putting food on the table, definitely not as glamorous as portrayed in Japantown posters of festivals and street fairs.

"What do we do now?" We always ask ourselves. "What are

our next steps?"

"First, we've got to reverse the negative news about our cybersecurity failures and Hell's Angels gatherings," says Yumi. "They're scaring everyone away and angering everyone in Japantown. Many merchants want us to leave town."

"Wonderful. How do we win their support?"

My sisters look at each, as they usually do when nobody has a clue what to do. We stick to our traditional tea and mochi routine and sit around brainstorming ideas on a whiteboard. Mari jumps up and sketches some ideas.

"Mayor Tiffany wants a Regenerative Fashion industry, right?" says Mari. "Let's give her one with Noh-Noh Girlz for real, not just online."

"How do we do that?" asks Emi.

"With real cosplay, Goth, and kimono designs. That's all we have to offer."

"What about my AI avatars?" asks Yumi.

"That too, once you and Steve figure out how to stop the hackers. Anyway, we need to host a supercool Regenerative Fashion show in the Peace Plaza during a major holiday like Labor Day when folks visit town."

My sisters and I start sketching ideas on our notepads and whiteboard, which overflow with words and images like a gigantic waterfall. There's one thing I love about my family; my sisters and mom never run out of ideas. In fact, we have so many good ideas that we often get lost and don't focus on a few workable ideas.

"We have ideas galore," I say. "How do we pick the best ones?"

"Cluster them," says Mari. "Let's use Regenerative Fashion as the theme then cluster everything around it like a lotus blossom to organize and present it."

Mari draws a big lotus blossom, filling the center with the words Green Fashion and the petals with music, food, fun, family, dance, martial arts, genders, women, working wear, sports, etc. Soon our lotus blossom overflows with ideas as Yumi and Emi join. In less than an hour, we create an entire Green Fashion Festival concept.

22

GREEN FASHION FESTIVAL

My sisters decide that regenerative fashion, or Green Fashion, will be our next attempt at reviving Japantown. We need the City's support, especially Mayor Tiffany, who wants to wear her green hemp gowns whenever possible at city celebrations to promote her green agenda and get re-elected. At least we have one supporter. Who else can we recruit?

"What about mom's friends?" asks Mari. "She got global coverage for her showdown with Mayor Tiffany, even if it was only a sales bubble, but at least it worked. Mayor Tiff totally lost face so she'll promote our Green Fashion event to stay in office."

"You are so – Goth," I say.

"She wanted to play hardball and lost to mom. How lame is that? At least we can give her a graceful and beautiful way to save face after supporting the City's attempt to evict mom's shop."

"I'd be careful," I say. "Mayor Tiffany is a smart cookie. We can't afford to antagonize her or screw up again. Steve says we're the "third rail" in city hall with all of our cyberattacks. She's smarting from the embarrassment and keeping her distance from us but enough water has gone under Golden Gate Bridge so she's still game to promote us again if we're careful."

"My cosplay girlz can make it easier for her," says Emi. "She loves having fun with young people. We'll give her cover. Let's Go for Broke and invite her to party with us."

"What do you have in mind?"

"Yumi's team can create a Noh Noh Girlz rock band with AI avatars to revive Virtual Japantown and grab attention."

"How will we create the real-world performances?"

"We can do a casting call again for singers and dancers. We'll just create fashions for the avatars and challenge entrants to animate

them with their songs and dancing."

"How will it differ from earlier?" I say.

"Just more green, both environmentally and financially. Regenerative fashion can create new green jobs."

"I'm all for that," I say. "I'll contact Steve."

Without ado, I notify Steve about inviting Mayor Tiffany to our open casting call. Desperately to win re-election, she agrees to hear our pitch. It will be like the good old days before she became mayor when she and Steve used to hang around Japantown Bowl having fun and imagining the future of the City. Now she can actually participate by wearing her green gowns."

"I love your lotus blossom approach," says Mayor Tiffany, wearing her casual green jumper for our brainstorming session. "It leverages the Cherry Blossom Festival in April and kicks off the fall shopping season. Maybe we can turn a Lotus Blossom Festival every Labor Day into an annual City event. That would give students and families something to do during the summer holiday and something to present at school in September."

"We can introduce it to K-12 schools and colleges. Green fashion is perfect since it links climate science with fashion, music, dance, foods and families."

"It will be my signature event," says Mayor Tiffany. "I'll wear a new green gown designed by local designers at each event."

Bingo! I was right.

"Our top fashionista!" says Mari. "You'll rock!"

"That's what I love about you Moriokas. You're always creating cool fashions without much money, even when nobody cares. Steve and I admire your passion and caring for culture and fashion. We need more of it to get people out of their post-pandemic funk. I see too many lonely, depressed people around town and wonder how we can turn them around. A Green Fashion Festival could create a whole new industry, which we need badly since remote work and AI eliminating jobs. We need something tangible -- yesterday."

"Let's move," says Steve. "Let's Go for Broke!"

"Hey, that's my line," I say.

"That's your dad's line. You just copied him."

Steve bursts out laughing, slapping my back like one of his bros. Mayor Tiffany and my sisters are delighted. We can work

together again. Perhaps we have the magic ticket out of poverty. It had better work. We do not have very many second chances left, not with big developers, supervisors and Japantown merchants breathing down our necks.

With one barrier down, we still need to convince Japantown merchants that rock bands will not attract another Hell's Angel invasion. It will take a lot of tea and crackers to warm them up to our idea since the older merchants are still living in the 1970s when they were young. The Youth Task Force loves our idea since many are cosplayers who love dressing up. They lobby the merchants and get their approval, as long as Mari's bikers meet outside of Japantown.

"That will kill my business," Mari whines.

"Do you want to kill Japantown?" I ask. "You can host your Goth fashion show at a park nearby, just far enough to avoid problems. Just make sure there are no alcohol and zooming around. We need OKs from the Black community and Rec and Parks."

"What if they protest?"

"Then a virtual event."

"Is that possible?"

"Yes, if they refuse to comply with City folks," replies Yumi. "I can just scan some bikers. You add your Goth designs and we're good to go."

"I'm being sidelined!"

"Better than being shut down. Look, we need to please Japantown merchants even if they were silent when the City tried evicting mom's shop. We either fit into their groove or it's no go."

"Even with our Go for Broke motto? We'll go broke first."

My sisters agree, moaning that Japantown folks love tradition, nonprofits and corporate J-Pop events, but nothing spontaneous, original or out-there. They're like dad's Bunraku puppets following tightly scripted traditional plays, not crazy puppeteers like us making up new stuff."

"Ok, girlz," I say. "How do we organize our green fashion show?"

"It's got to be paradigm-busting and breaktaking," says Yumi. "Like a hard rock festival in VR, but better than real life."

"With the coolest cosplay outfits ever," says Emi. "I'll put out a call for Noh-Noh Girlz performers."

"Do you know any singers and dancers?"

"A few. Most are designers so I'll give them ideas and let them create their own outfits -- fresh, new designs."

"My Goth designers can dance too," says Mari. "They're great at breakdancing. We need street ballet too."

"Street ballet?"

"Cosplay ballerinas dancing to Stravinski and Kitaro -- East-West street opera."

"I've never seen that. Tell us more."

"My cosplay girlz can dress as Russian and Japanese ballerinas and mix J-Pop tunes with famous operas for weddings and holidays."

"How would they do that?"

"With drama and tragedy. They open with Stravinski's "Firebird" then "Petrushka" about the loves and jealousies of three lovers, "The Soldier's Tale" about a soldier who sells his violin to the Devil for a book to make him wealthy, then "Apollo" and "Agon," which blend music and motion."

"How do you know that all?"

"Google. Just kidding. We learned it in ballet class when I was in the fifth grade. Great stuff and perfect for promoting my new "Rites of Spring" Goth collection."

"That's fresh and it will interest the Russian community. Mayor Tiffany needs every vote that she can get. Ballet is definitely less threatening than hard rock so more people will come."

"Just don't abandon us bikers," says Mari. "We want to be part of the celebration too."

"We're not abandoning you. Just separating Jewish families from bikers. Otherwise, the City will never approve it."

"Point taken," I say. "Let's open with East Meets West cosplay fashion contests for street ballet to attract everyone."

"Mayor Tiffany can wear her beautiful green gowns with mom's Heian designs and regal Russian tiaras and necklaces."

"Just make sure to encourage people to visit my Goth green fashion show."

We sympathize with Mari since we are all struggling and trying to find our tribes. We always thought of her as a lowbrow biker who only listened to hard metal and grunge music so her love of Stravinsky and ballet surprises us. I guess we do not know her very well.

"Don't look at me like I'm weird," says Mari. "I studied the classics like you. I don't want to be provincial. I'm just into hard rock and country too. It's some of the greatest Americana music."

"We're all making this up anyway so we might as do our best and see what sticks," I say.

"I'll ask my music friends to mix hard rock with Stravinski, Kitaro and rap music," says Emi.

"Sounds like confusion. How would that work?"

"Rappers could sing while cosplayers breakdance to a hip-hop versions of Kitaro."

"What does that sound and look like?"

"Like fairies in a "Midsummer Night's Dream," but with rappers dancing hip hop to soothing and ethereal Kitaro music."

"Fusion hip hop. Very San Francisco."

"That's the point. We can call it Hop City, the San Francisco Renaissance where we blend Goth, cosplay, soul, rap or hip-hop into a new San Francisco look and sound. We can challenge cosplayers to design their outfits, write lyrics, and play music to tell their stories. No repetitions of classics, but fresh, creative storytelling."

We sit back, exhausted by the rush of ideas, but satiated and happy, as if we have just rediscovered gold – the cultural gold lying within us. We used to search for gold outside of us. Now we can mine our inner gold. It's in our hearts, minds and communities.

"Dad said it best: Each moment is gold," says Mari. "I'm beginning to see what he meant. His puppets were a way of mining our cultural gold and showing it to the world through our stories, not just retelling stories from Japan."

We sit around, sipping tea as mom and dad always did when they were planning new Bunraku plays and fashion shows.

Inspired, our Green Fashion show kicks off with a blast of social media marketing to our fan clubs. Mari rallies her biker friends on the West Coast, but East Coast bikers organize group tours since they want to enjoy the summer with their "Ride for America" group tours to support cities and towns. Emi's cosplay fans organize thousands of mini-clubs to design green collections, which pop up on their websites like flowers blossoming. Yumi's Cal teams organize students and alumni who capture and animate Goth, cosplay and green fashions with their AI avatars. I allow them to show their fashions in Virtual Japantown, which looks like a free-for-all fashion

bazaar. Steve's Virtual Fillmore platform supports the collaboration, online fashion shows, cybersecurity and e-commerce so we do not have to worry about tech issues.

"We're mining true gold!" says Mari. "My biker buddies are so excited that they all want to visit Japantown."

"Oh, oh, the deluge," says Emi, with a worried look on her face.

"Don't worry," says Mari. "They'll be disguised as Russian ballerinas and princes."

"Right," I say. "Leathered Barishnokovs on bikes."

Our Green Fashion festival revival goes better than planned. Not only does Mayor Tiffany kick it off in her glorious green gown with a long tail at our first annual Green Fashion show, Mari organizes a phalanx of bikers in original Regenerative Goth costumes made by recycled leathers and kimonos, while Emi's cosplayers unveil a stunning array of whimsical "Summer of Love 2.0" green fashions created from hemp and biomaterials. Our mini-parade down Post Street into Japantown and our Virtual Japantown is an historic first. What makes the parade even more special and sensational is that the City's police, fire and healthcare employees wear innovative green workwear using totally recycled materials.

But Emi is frustrated by the regenerative fashion theme. She wants to spread her wings and do her own thing: a full-out Cosplay City where everything is possible, not just green fashion which limits her to recycled clothes and biomaterials.

"I just want to fly," she says. "To soar with the eagles, not just bikers, cops and nurses."

"Then do it," I say. "Show us your stuff."

23

COPYRIGHT CITY

Emi hunkers down with her cosplay girlz to design Cosplay City, the name of her new shop. She wants it to be the coolest cosplay outfit store in the Bay Area. She already has lots of fans cheering her on but faces some big challenges. Like us, she has virtually no savings, just lots of recycled clothes, has never run a business and knows nothing about budgets, banking, payments, invoices and accounts receivable. Except for mom, we are all flying blind financially so we cannot offer much help.

"I told you girls to study harder in school," says mom, wagging her finger at us.

"They don't teach entrepreneurship and accounting, just memorization for STEM and college admission tests. Totally useless for running our businesses."

"You should have listened to dad. He had Kimono Minds running smoothly."

"It was your business. Dad didn't train Brad about finances, did he, Brad?"

"Emi's right," I say. "He didn't teach me anything about bookkeeping. I was just handling lights, shipping and set designs for your kimono fashion shows and his puppet plays."

"That's no excuse. You're the man in the house now and need to step up on finance. We're depending on you to keep us afloat."

"Me! I'm just a high school junior and a robot designer, not an aspiring financier."

"It doesn't matter. We are all aspiring financiers if we want to stay afloat. Remember what your father always said: All biz is showbiz."

"That was for your shop and his puppets, not our hobbies."

"If you want to turn your hobbies into businesses, you need to learn business fast. We have no money to fund your tuition."

Damn, we are screwed. Mom wants me to carry dad's load but I know absolutely nothing about finance. I wish dad had shown me his accounting books and I had asked questions, but that was off the table. What would most teens do squabbling with parents over money? Get out of the way like I did and focus on schoolwork and my robots.

"What do we do now?" Emi asks the proverbial question that haunts us day and night. "We are our options?"

I pause for a moment then click my fingers.

"Steve! He's a seasoned CEO. He might lend us some seed capital."

"I wouldn't count on it."

"Never hurts to try."

I text Steve who is bored in another campaign fundraising dinner. At 9pm, he shows up at our front door.

"What's the issue?" he asks, scanning our worried faces like a soldier.

"Emi wants to launch Cosplay City online to promote her Noh Noh Girlz fashions," I reply. "But hackers have destroyed everything and we have no money to rebuild it. Can you help us?"

"No problem," says Steve. "We can re-announce your cosplay design contest and accept submissions, but there's just one problem."

"What's that?" asks Emi.

"Mayor Tiffany says the city attorney warned her about promoting AI-generated art to avoid copyright lawsuits. She says everything AI is on hold with City-hosted events until we get legal clearance."

"How long will that take?"

"Who knows. IP holders are litigious so lawsuits could go for years."

Emi looks at me with disappointment.

"We'll never get Cosplay City off the ground."

"I wouldn't say that. You can launch if you advise artists not to use AI images for designing their VR fashions to avoid lawsuits and court injunctions."

"Court injunctions?"

"Plaintiffs could shut you down until experts review and clear you. That could take months or years."

"No, no, no, no, no!" moans Emi. "I'll be 30 by then and stuck working as a corporate drone for some fashion company."

"It's not that dismal. You can launch Cosplay City. Just post your policy about not accepting AI-generated fashions on your homepage and say that any designs using AI will be taken down immediately."

"How can I be sure if it's copied by AI?"

"Easy. I've set up AI copy detection systems on Virtual Fillmore since we're running into the same problem with copyright holders."

"Wow, Virtual Japantown is turning into a regular law class. AI gurus were touting limitless creativity using their systems and now we find that legal issues will stop us."

"The joys of America. We're the most litigious nation in the world. It's gotten so bad that Mayor Tiffany has invited Berkeley, Stanford and Hastings law professors to advise the City on AI copyright compliance."

Emi and I look at each with dismay.

"And I thought launching Cosplay City on our Virtual Japantown platform would be a snap. Just drop it in and make money."

"Mayor Tiffany and I wish it were that easy," says Steve. "My compliance team is reviewing every object and avatar in Virtual Fillmore since we're dealing with jazz, rap and hip hop artists who are already suing the big music studios. I might have to totally revamp my business."

"Damn! Maybe the City should launch Copyright City first so we all don't get sued."

"Great minds think alike. As a matter of fact, Mayor Tiffany and the city attorney are planning it as we speak. If we move fast, we'll have the first Copyright City platform next week to deal with AI compliance and advise other cities."

"Wow, Mayor Tiffany moves fast!"

"She was a jock Navy fighter pilot and "Top Gun" trainer, remember? Our rivals are now copyright attorneys. We're going to see a legal battle royale to top all copyright fights in history."

As usual, Steve understates the severity of the situation to

avoid needlessly scaring us, but he is right. Not only do copyright owners challenge the City; every online store and studio in the world is stopped by swarms of lawyers and boycotted by artists everywhere. Fresh online content comes to a screeching stop. Hollywood creators boycott the studios and TV stations using AI likenesses, as they threatened in their union walkouts. California is virtually shut down in Hollywood, Silicon Valley and Sacramento as hordes of lawyers converge onto the two regions like locusts, which satirists call the "Day of the Locusts."

"Shit," moans Emi. "Why does this shutdown have to happen now? We were just getting momentum."

"That's life," says Steve. "Remember, I keep telling you: Life is like football; the ball usually bounces the wrong way. This time the ball is AI. We just have to scramble, recover and move on."

"Move on to what?"

"The real world. We can't go online until the major AI issues are resolved so we have no option but to go ahead with a real Cosplay City event in Japantown and the Fillmore."

"For real?"

"For real. Sometimes, we Army grunts know better than flyboys and flygirls like Mayor Tiffany who get all caught up in soaring fancy loops and lose touch with real people. To win, we need boots on the ground."

24

COSPLAY CITY

Yumi has ambitious plans for Cosplay City so she bans the use of AI to avoid copyright violations and revives the old fashion method of handcrafted fashion designs and in-person shopping. Within days, her fans and friends show up. Her pop-up becomes the hot new place to meet in Japantown, emerging like a beautiful flowerbed with hundreds of models strutting their stuff in cool outfits – Ohlone princesses, Japanese samurai, Indian goddesses, French viscounts, English noblewomen, and the inevitable Jedi warriors. After being isolated and lonely for so long during Covid-19 lockdown, her cosplay friends are thirsting to reconnect with each other and show off their outfits.

"I'm in seventh heaven!" says Yumi. "This is my dream come true. I could live like this forever!"

"Now you know why I prefer the good old ways," says mom, beaming with pride. "But you need to attract visitors during the week, not just weekends. How are you going to do that?"

"Social marketing."

"Nice, but people are busy. They won't take off from school and work to show up. You need something compelling, a must-see event, like I do with themed fashion shows. Any ideas?"

Mari, Emi, Yumi and I sit around brainstorming and sketching ideas. Mom is right; we cannot just rely on word of mouth. We need a big drawing card. We toss out a few ideas, but quickly nix them since they do not feel right.

"God, it's hard to attract shoppers during the week," says Mari. "My business is dead all week."

"We need to do something different," asks Yumi. "Something fresh, original and new."

"Like what?" I ask. "We've tried all sorts of stuff and they've

backfired."

We sit around mulling, doodling and sketching. Our family is famous for doodling when we are stuck or bored, just like at school, but it does not always work. We usually end up with deadends. We desperately something in-person or we are out of business. What could work? What's the spark? Who? What? Where? How? This is the curse facing every inventor and designer.

We are depressed because the Peace Plaza mall is under construction for a few years, which is scaring away shoppers.

"At this rate, we're out of business in a few months," moans Emil. "All of our efforts for nothing. My friends think Japantown is closed for years so they're going elsewhere."

"What can bring them back? asks Mari. "Goth fashions?"

"That will just bring your biker buddies," I say. "We can't do that again."

"What about a mini parade?" asks Emi.

"To see what? There's nothing to see but construction equipment."

We sit around, totally stymied for hours then Yumi jumps up.

"I got it!" she says. "Virtual construction! I can create a virtual construction site with AI avatars. People love watching construction equipment at work, especially kids. I can create a virtual construction site with AI avatar workers using tractors, backhaulers, trenchers, and mini-cranes."

"But that's just virtual," says Mari. "People will just view it online and not visit Japantown."

"They will if I add AR images of moving construction equipment at the fence surrounding the Peace Plaza."

"How would you do that?"

"Easy. Just show equipment at work on smartphones and let visitors pick different equipment, drop them into the construction site and manipulate them – like moving Tinker Toys."

We all sit back, trying to imagine the scenes so Yumi messages her Cal friends who quickly design mini-cranes and backhaulers with AR that they drop into the Peace Plaza in our Virtual Japantown. It happens in minutes.

We walk down to the construction site, pull up Virtual Japantown and see the mini-cranes operating.

"Yumi, you're a genius," I say.

"Not me. My friends created it."

Yumi asks her friends to keep creating construction equipment that online visitors can drop into Virtual Japantown, but she surprises us with her next move – virtual cosplay avatars. Within minutes, her coders take her virtual cosplay fashions, drop them onto avatars of all ages and sizes, and display them in her pop-up shop. Within hours, Emi's Cosplay City shop is fully tricked out with a variety of cosplayers wearing multi-colored construction clothes. We will be the world's first construction wear fashion show.

"Ta da!" she says. "We just expanded into a totally new market. Your wish is my command."

"Brilliant," says Emi. "We have a chance."

"And my pals will alert the entire Cal alumni network about Cosplay City and invite them to our shop."

"What about my Goth fashions?" says Mari.

"You can add your Goth construction wear designs too."

I am rather confused but surprised by Yumi's new idea. Who would dream up construction outfits? It opens the door to all types of working wear for doctors, nurses, salespeople, inspectors and other onsite workers.

My sisters move fast like the SF Warriors during the playoffs. That is one thing I love about our Morioka family. We don't just mess around but get shit done when others just yak-yak-yak. We're designers and doers, not just talkers like most people.

"We can host a Cosplay City mini-parade around Osaka Way on Buchanan Mall," says Yumi. "It's big enough for a hundred cosplayers."

"Can we get permission?"

"If we ban bikers."

"I'm devastated," moans Mari. "My Goth fans will feel left out."

"Don't worry. We can create a Goth biker event in an open parking lot in the Lower Fillmore. Steve can help with City and merchant approval since the Fillmore shops need a lot more foot traffic."

Mari hustles to get permissions from merchants and the City, which happen quickly, thanks to Mayor Tiffany and Steve. It pays to have friends at the top. If we did not have them, Japantown and the Fillmore would be sitting ducks for big developers and billionaires.

Emi launches Cosplay City online to promote her real pop-up shop. That is how we will reimagine Japantown – virtual then real -- one virtual brick at a time. We just need bulletproof cybersecurity by Steve's team.

25

HIP HOP CITY

Emi's Cosplay City concept is wonderful but it only attracts young people during weekends and festivals. How can we attract them on weekdays, especially during the slow winter months? Mari, Emi, Yumi and I resort to our only hope: brainstorming new ways to get out of our financial limbo. Mom cannot help since she is focused on keeping our shop afloat, which keeps me busy with logistics and accounting. I barely have time for homework and my own robots.

"Now what?" asks Emi. "I've got dozens of my top cosplay designers showing their coolest outfits but they're not drawing enough traffic. Any ideas?"

"How about dancing?" I suggest. "All my buddies can't find dates and want to meet women in person. Online dating doesn't work. It's a total disaster for them."

"And for women too," says Mari. "I'm always bombarded by mansplainers, married men, predators, and ugly creeps. Where are all the good-looking, kind men in SF? Are there any? My girlfriends have given up on online dating. We would rather work and travel to find Mr. Perfect. Bars, yoga classes, and street fairs don't work. Volunteering is hit or miss. We need safe places to meet people in person. What could work?"

"How about dancing?"

"Like salsa?"

"No, all types of dancing – breakdancing, tango, country, disco, anything that moves."

"That sounds so retro."

"Beggars can't be choosers and we can invite dance and community groups organize their own dance styles. To engage watchers, we can invite rappers, poets and singers to tell stories to hip hop dancing."

"Hip hop? That's limited."

"We can expand the repertoire of dancing, singing and music to make it open and fun. Emi can challenge groups to wear cosplay outfits – like a musical. City folks love to dress up."

"So a Hip Hop City venue?"

"With singing, rapping and dancing, but no motorcycles."

"No bikes! That's discriminatory," says Mari. "I thought you said we would be open and inclusive."

"OK, but they have to get off their bikes and dance like the rest of us."

"But their wheels are their shoes."

"Perhaps they should walk for a change. Better for their health and social skills, and they won't scare away people."

"Can they breakdance on small ebikes?"

"You are desperate. Has it ever been done?"

"Only by kids too young for biker clubs."

"We'll need a separate area for them."

"I'll ask Steve how to get City permits and bicycle sponsors."

"Sponsors! I'm interested."

When I mention money, my sisters move extra fast. Within days, they invite cosplay and Goth designers and bicycle sponsors to Emi's Cosplay City, a first-ever with hip hop breakdancing. It is a crude mash-up but better than no business at all.

"Mayor Tiffany loves your idea," says Steve. "She invited bike clubs since SF is promoting bicycle lanes citywide. Tiff wants bicycle destinations around town, like Japantown, where cyclists can show off their tricks and outfits. A perfect way to promote green fashion, cosplay, e-bikes, and bike lanes at the same time."

"She's more creative than I thought," says Emi, jumping up and down like a kid. "My cosplay friends will love me."

"And my biker friends!" says Mari.

"Bring 'em on!" says Steve.

And bring it on they do. Emi's cosplay buddies rally hundreds of fashion designers and thousands of fans. Mari invites e-bike sponsors and performers. Steve picks hip-hop singers and dancers from his Virtual Fillmore community. Without spending a dime, we mobilize a thousand designers and fans to perform on Post Street, which overflows with crowds after 6pm. Japantown looks like a big

cosplay fantasyland, rocking with hip-hop singers, breakdancers, e-bike performers and fans in cosplay outfits of all colors, designs and cultures. Our young people are so imaginative that they make older J-Pop folks look seriously retro. J-Pop, K-Pop, C-Pop and other pop culture fans compete to design the most creative outfits, dressing up as bamboo trees, volcanos, deer, godzillas and gods, goddesses, princes and princesses, fairies, goblins, ghouls, zombies and sorcerors – all singing and breakdancing to hip-hop tunes from over 200 ethnic communities. Within weeks, Japantown has become Hip Hop City. My family and our designer friends are saved financially.

The biggest laugh is elicited by Mayor Tiffany who shows up wearing a huge green bouffant wig and a tight glittering emerald gown and dancing to R&B music with Steve, who is dressed up like a cool 1950s soul singer.

Steve shouts: "We're SF! When we're down, we party and jive!"

No wonder he became the first Black unicorn CEO in the Bay Area with his Virtual Fillmore platform. Tech is cool, but soul sells better. Maybe that is our future.

26

UNITY PLAZA

Emi's Cosplay City cum Hip Hop City is the perfect opener for Mayor Tiffany's bold vision of reviving the "Heart of the City" by totally reimagining Japantown and the Lower Fillmore and undergrounding Geary Boulevard to create a new Unity Plaza. Our launch educates everyone about the past and our vision for the future. City promotions mention that the Black and the Japanese neighborhoods were nearly eliminated when urban renewal became a nightmare of mass evictions and bulldozing, replaced by faceless housing projects and community-splitting expressways. Once filled with beautiful Victorians, the "Western Addition" became a ghost of its former self, filled with sad-looking, low-rent housing projects surrounded by hills of wealthy white homeowners living in beautified "painted lady" Victorians – a tale of two cities. The new Japan Center mall in the 1960s created a buffer separating rich, white homeowners from poor Black families, many who were evicted as "urban blight" and moved to Bay View, Hunters Point, and the East Bay. "The Moe" became a demilitarized zone of WW2 concentration camp returnees and Black families. "The Last Black Man in San Francisco" film about a nostalgic young Black skateboarder squatting in his family's old Victorian was also a story about Japanese American families who lost their Victorians.

 My parents arrived in 1990, forty years after the damage had been done, but evictions and gentrification accelerated with the 1990 dot.com boom, which lured big developers and rich tech bros seeking to renovate the remaining Victorians, including ours. As my father moaned: "There's no rest for us poor." The City and realtors constantly hound us to sell our Victorian for their fancy new plans, but my parents held firm and refused all offers. We are known in city hall as stubborn holdouts so I am learning about the harsh realities of

urban renewal from all the buyout offers pouring in.

Mayor Tiffany wants to save Japantown and Lower Fillmore from further evictions and gentrification but she faces corporations with billions of dollars – Goliaths dwarfing our Davids. She wants to honor the communities and reclaim Geary Boulevard for the remaining Black and Japanese families as part of her Black Redress program, the first in the nation. The "Moe" would test her model city idea: Can poor communities revitalize themselves through bottom-up grassroot activism, instead of relying exclusively on top-down government and corporate redevelopment megaprojects favoring the rich?

Her idea to underground Geary Boulevard to create Unity Plaza is brilliant. Like the new Presidio Overlook Park, which provides spectacular views of the Golden Gate Bridge and the bay, Unity Plaza can transform an ugly expressway dividing the two communities into a beautiful plaza filled with tumbling water, an Afro-Asian museum, shops, affordable housing, nonprofit offices, mini-theaters, community centers, studios, meandering gardens, performance spaces for dancing, tai chi and martial arts, solar sculptures that dance in the evenings to make spaces safe, and street food vendors with tables and performance stages. It would be the diamond in the heart of the city and a dream come true for artists and shopkeepers. My mother and sisters are so excited about hosting street fashion shows and musicals there that we cannot sleep at night.

"We would have the coolest park in the City!" says Emi. "Imagine a plaza filled day and night with cosplayers!"

"And my e-bikers!" says Mari.

"What does Mayor Tiffany have in mind?" I ask. "And where will the money come from?"

I worry about getting too optimistic since visionary plans often go awry.

"Unity Plaza will be a public-private partnership," replies Steve. "Public infrastructure and private investments. It will be an historic first -- a place to unify the City, not resegregate it into racial blocs like now. This new plaza can showcase all of our cultures --- Japanese, Black, Jewish, Ayatusch Ohlone and hundreds of others. It will be a commercial version of the UN Plaza, but livelier, family-oriented and more fun. It will be a place to meet people and make friends. Mayor Tiffany wants to make it the "Multicultural Heart of

the West" – decorated by dozens of heart sculptures by artists from all cultures."

My mother, sisters and I sit back, dazzled, but I remain skeptical. I cannot imagine how to turn the half-empty Lower Fillmore, which is filled with parking lots and empty storefronts, into a gleaming plaza. It looks like so sad today, like a neglected member of our family.

"To bring it alive, Mayor Tiffany will work with all music and cultural groups in the City, starting with the Japantown Youth Force, SF Jazz Center, Rosa Parks Center, Jewish Community Center and other long-time residents who know the "Moe" like the back of their hands. She wants to build Unity Plaza 'of the people, by the people, and for the people,' as her gift to the City."

"What are the odds of undergrounding Geary Boulevard and raising enough money to rebuild the Moe?" asks Yumi. "It sounds like a pipe dream to me."

"Anything is possible in the City if you have communities behind you. One thing I learned in city hall: The squeaky hinge gets the oil. The louder the squeak, the faster the oil."

"Are you sure?"

"We're studying the past -- Ghirardelli Square created by ambitious developers, citizens stopping highways in the 1950s, angry Fillmore residents shouting down SF Redevelopment Agency director Justin Herman (who later died of a heart attack in 1971), tearing down the Embarcadero elevated highway after the 1989 earthquake, and the Multimedia Development Group issuing a manifesto in 1990 declaring "SOMA: The Multimedia Capital of the World." Citizen groups have toppled mayors, supervisors and bureaucrats so anything is possible."

"Including Mayor Tiffany?"

"Which is why she is so motivated to save Japantown and the Fillmore. The election will be close with Bill Ting already capturing half of the Asian voters, so we need swing voters."

"That's us: Blacks, artists, Russians, Japanese, Koreans and other local residents. We're small but visible and noisy."

"Exactly, we squeak a lot. Billionaires are organizing to kick her out of office and positioning Lower Fillmore as a test case since we are politically weak. Once they win here, they aim to take over the Mission and other cultural districts. If we don't stand up now,

there will be nothing anything left of Japantown and the Moe -- no Black families, no Japanese and Asian shopkeepers, just big developers, rich folks, luxury condos and chi-chi tourist shops. That's why developers want your mother's kimono shop. She's key to the entire block since she has global recognition since her showdown with Mayor Tiffany."

My sisters and I look at each other, worried.

"We have that big target on our back?" asks Mari.

"A big red rising sun, but we'll show the our sun rising over a Japantown without luxury highrises."

"I love the imagery," says Yumi. "I'll create a graphic with Peace Plaza pagoda."

"Geary Boulevard is our Alamo?" says Mari. "My biker bros will defend us against bulldozers."

"You had better move fast. Developers are lobbying supervisors to get approvals for major projects in Lower Fillmore. The Geary underpass is our last chance. If we lose this battle, I guarantee you that we will lose the entire Lower Fillmore. There will not be a single Japanese, Black or Asian family or shopkeeper left. The Moe will be filled by crazy rich Asian and white corporate investors and families with fountains of money, but no talent or memories for our past. We'll go from Soul City to Ghost City, like other developments in Chinatown, Dogpatch and the Mission. Total cultural amnesia..."

"Shit, we can't let that happen!" says Mari. "My bros and girlz will stop them before we give up an inch!"

"Then support Mayor Tiffany's vision for Unity Plaza. This is a huge opportunity and our last chance to save the Moe from permanent extinction. If we do it right, the Moe will become the "Harlem of the West" again with Asian, Ohlone and Latino cultures for the first truly multicultural, multiracial center on the West Coast. We will be the City of Lights."

"You sound like a PR guy for the City," I say. "With all those high-faluting visions and words."

"Where do you think Mayor Tiffany got her ideas? I've been toying with these ideas as a kid since my father was shot down in cold blood by the cops outside his Fillmore nightclub. I've always had nightmares about his shooting and thinking about taking revenge, but I don't want to hurt people, just save the Fillmore and Japantown.

It's our home. Mayor Tiffany and I went to elementary school here. Seeing the constant evictions around us, we vowed that we would harness our anger and channel it into something useful and productive – like Virtual Fillmore -- and now Unity Plaza, but this time we will go from virtual communities to real communities."

My sisters and I sit back, stunned, realizing for the first time the depth of Steve's sorrow and anger. He never talked much about his father's shooting when the cops mistook him for a break-in thief at night when he was closing up the "Hop City" nightclub in the 1970s, which was patterned after his grandfather's "Bop City" in the 1940s. My sisters and I never asked many questions since we knew it was a sensitive topic for him. When we mentioned it, Steve would clam up and become silent and depressed, as if the air had been sucked out of him. His normally gleaming eyes would tear up and become cloudy. He was no longer with us in the room, but somewhere far away to the day his father was shot and he became the walking dead.

"Steve," says Mari. "We're sorry about your father. We lost our dad but he wasn't shot."

"Don't worry," Steve replies. "It's just tough to talk about him. I need to move on. We need to do something to turn my anger into something positive, otherwise I'll go crazy. I don't want to become a crazy Black man angry at the world. I want to build something awesome and beautiful that unites the City, not divides and tears it apart."

My sisters and I come over and give Steve our big Morioka family hug. He smiles, sheepishly putting his head into the center of our circle, and we give each other one, long bear hug.

"We will succeed," says Steve. "We will overcome the big developers. Mayor Tiffany will win this fall."

"Let's Go for Broke!" says Mari. "Just like mom."

Steve creates a virtual model of Unity Plaza using his platform for Virtual Fillmore and Virtual Japantown. His developers work fast so they design the plaza within days, complete with the solar sculptures earlier designed by our friend Yoko Hamabe, a sculptor who moved to the Bay Area from Osaka twenty years ago. Totally tricked out with *akachochin* food stalls with red lanterns and a long meandering Japanese garden with native plants and rocks connecting oval public

places for singing and dancing, the plaza is absolutely gorgeous.

"We did it," says Steve. "At least virtually. Now comes the hard part. Getting City approval for it and finding developers on our side."

"Any obstacles to getting City approval?" I ask.

"Just money, as usual. Without funding, the supervisors will automatically reject our plan. No money, no plaza."

"Any ideas on how to raise money?"

"Crowdfunding to get attention, but that will only raise small amounts of money. We need big money to build the plaza."

"Like how much?"

"Up to one billion dollar since the undergrounding of Geary Boulevard, building affordable housing, toilets, and the Fillmore Museum will be costly."

"We don't have a chance. We're back to billionaires again."

"Not so. If we host performances and sell products in Virtual Fillmore and Virtual Japantown, we can raise tens of millions of dollars per month if we do it right."

"How?"

"That's where Noh-Noh Girlz cosplay contests come into play. We need a series of contests to attract corporate sponsors, donors, music ticketing, and merchandise sales. I know how to do that with Black music in Virtual Fillmore, but few people outside of J-Pop fans know Japanese and Asian pop music."

"What about cosplay outfits? Can that work?"

"Mayor Tiffany and I are talking about it. It's a crowded market so she thinks our only chance is regenerative fashion – green fashion. She thinks the City should become the Green Fashion center for the world, just like it positioned SOMA as the Multimedia Capital of the World in the 1990s."

"What does she have in mind?"

"A big blowout Green Fashion show to knock off everyone's socks: international cosplay fashions from all designers around the world, not just the Bay Area. She wants to turn SF into the "UN of Green Fashion. She needs women voters this fall to offset Bill Ting's success with Chinese voters."

"Green vs. Red," says Mari. "That will be one hell of a showdown."

"Mostly green, as in greenbacks."

We burst out laughing since Steve is serious. Without money, nothing will happen with Unity Plaza.

"It's all-or-nothing this fall or Mayor Tiffany and I are back on the streets again and we would have to create Unity Plaza as citizens, which would be a hundred times harder."

My sisters and I sit around, looking at the beautiful virtual models of Unity Plaza filled with Yoko's solar sculptures, flowing gardens and Japanese, Afro, Chinese and other foodstands.

"This is all just a midsummer night's dream if we don't raise enough money," says Steve. "It's my dream. I have a dream but I can't be truly happy if it's not 'We have a dream.' We need to do it together – in Unity Plaza."

27

BOP CITY

Emi's Cosplay City cum Hip Hop City is the perfect opener for Mayor Tiffany's bold vision for reviving the "Heart of the City" by totally reimagining Japantown and the Lower Fillmore. How can we reclaim lost land and rebuild it as thriving ecovillages? How can we do it when the City is running a huge budget deficit and neither community has wealth or big builders? Hip-hop is fine for Emi's cosplayers but not enough to turn around the area. What could work? My sisters and I sit around brainstorming with Steve.

"We could expand Hip Hop City into a new town concept," says Mari.

"What do you mean by that?" I ask.

"Imagine dozens of cosplay shops in the Fillmore and Japantown. Thousands of folks would come."

"But it would be limited to them," says Mari. "What about my Goth fans?"

"Throw Goth Cosplay events," says Emi. "Then they can fit into Hip Hop City."

"Kinda lame to me. My biker friends don't want to show with frilly J-Pop and K-Pop girlz and boyz. They're real folks – hardworking plumbers, builders and mechanics, not metros. They like growling engines and leathers, not fancy schmanzy rainbow glitter."

"How about breakdancers?" says Steve. "We need music and dancing to attract people, not just fashion shows."

"What do you have in mind?" I ask.

"Imagine inviting dance troupes of all backgrounds to a breakdancing competition where the winners get free coupons to the Japantown bars, shops and restaurants."

"How does that differ from other breakdancing contests?"

"They would have a theme."

"Like what?"

Steve pauses a moment to reflect, tapping his fingers on his palm, as if playing a small taiko.

"I got it! Bop City! My grandfather ran a nightclub called "Bop City" which was the swinging center for the Fillmore when it was called "Harlem of the West" during the 1940s and 1950s. He held dancing contests that packed the place. People would come from all over to compete and show off their coolest clothes and steps. We could do the same, but open it up and go way beyond Black music to all world music."

"Tell us how that would work."

"I would create Bop City first online in Virtual Fillmore to advertise the contest. People could enter their avatars in our online breakdancing contest."

"But that requires learning AI to create the avatars."

"I'll provide the biodynamic dance sequences of all types of dancing – tango, salsa, hip hop, country, ballet, etc. Contestants can just pick their avatars and dance styles, dress them up in their own fashions, then show them breakdancing."

"Just breakdancing on their backs?"

"Both on the ground and standing up to make it interesting and more difficult. The best performances win. It's simple. We just need to let people know."

Steve messages his teams and within minutes they pull AI avatars from their library, dress them in various fashion styles, then animate them as dancers.

"See, it's not that hard. Anybody can do it, but they need to be creative in fashion design and dance choreography. It's like creating a musical or ballet; you need to know how to blend music, costume, dance, lighting and storytelling, just like Broadway and Moscow ballet. We invite the finalists to Virtual Japantown for the showdown. It will be fun. If we do it right, we'll get tens of millions of viewers and millions of visitors over time."

"Are you sure? That's a lot of people."

"Virtual Fillmore gets them all the time, but we're only online. Virtual Japantown can be linked to the Peace Plaza for the final showdown, both virtual and real world. We'll call it Bop City to give it pizzazz. We need to fascinate and attract people."

Steve and his team go to work with Yumi's AI team to create Bop City as a musical fantasyland linking Virtual Japantown and Virtual Fillmore with Japantown and the Lower Fillmore. They create a celebratory Afro-Asian link between the two communities, which is lined with bamboo groves and cherry trees in Virtual Japantown and red maples and Southern white oaks from the South in Virtual Fillmore. The archway looks like a magical bridge with twinkling solar sculptures designed by Yoko Hamabe. Its beauty will stun us.

"Let's create beautiful plazas, not just the same cold, rigid towers as usual," says Steve. "If we want people to visit, we need to make it chill, cool, relaxed, friendly and fun. No more Snob City architecture for me!"

"I'll second that," says Mari. "My biker friends always get the cold shoulder here, even though they are smart and educated. We need to make Japantown and the Fillmore welcome to everyone, not just the elite."

"I'll third that," says Emi. "My cosplay friends are always mocked so they have nowhere to show their fashions. We can be the safe zone for cosplayers."

"I love it," says Yumi. "Cosplay avatars are more interesting to design. It's like working for Disney or Pixar, not some staid office."

"Well, girlz," says Steve. "It looks like we've got the basic concept down pat. Now let's build it for VR and real."

Our Bop City comes up like a field of dancing mushrooms in "Fantasia," which is our inspiration. Yumi and Steve have fun creating AI avatars of all colors, ages and sizes from around the world. Steve takes a standard avatar, colors it, adds wild hairstyles then gives it to Yumi for adding cosplay fashions designed by Emi and her friends. Soon, Virtual Japantown looks like the workshop of the Seven Dwarfs busily creating stylish avatars and putting them to music as examples for the contestants. Our archway and oval plaza spaces fill with avatars of all types, looking like the streets of San Francisco during festivals and parades.

"We did it!" says Yumi, showing off a troupe of Japanese, Korean, Okinawan and Filipino breakdancers dressed in traditional and rainbow cosplay outfits. "We're the first Bop City performing arts community in the world.

"Others will copy us," says Steve. "Like Virtual Fillmore, which has dozens of partners in the Americas and Africa. If we do it right, we'll have Bop City International fashion and breakdancing shows and expositions."

"You think big," I say. "We're just beginners."

"We have a headstart with Virtual Fillmore. We will show the world how to revitalize dead downtowns and retail districts from pandemic shutdowns and remote work."

My sisters and I pinch ourselves, not believing that we were able to create the basic Bop City platform so fast. If it were not for Steve, we would still be struggling with sketchpads. No wonder he's the first Black unicorn CEO; he eats, sleeps and dreams virtual worlds then builds them. We should be so lucky.

But our mother looks worried since we are ignoring her. Our Kimono Minds shop looks lonely and forlorn compared to Bop City. She congratulates us but you can tell she's unhappy. My sisters and I feel bad so we need to do something to cheer her up.

"We know mom; one builds the future on the past," says Mari. "We'll help you."

"I know it's more exciting and fun to design coplay, Goth and AI avatars, but we come from a long history of Kyoto kimonos. Please don't forget kimonos. Don't forget who you are."

"We won't, mom," says Emi, hugging mom. "We'll never forget kimonos."

My sisters, Steve and I surround mom and give her a big, long Makioka family hug. We can see she feels lost in our virtual world of pop culture and, now, bop culture. She needs to feel loved and wanted. We need to do something to show her that she is not forgotten, not spout empty words as we often unthinkingly do.

How can we integrate mom into Bop City? That's a puzzle for all of us.

28

KIMONO BOP

After years of struggling, our mother finally realizes that it is useless to ignore our dreams. We Moriokas are strong-headed innovators like her, which is unusual in Japantown since most young people seek safe professions like medicine, law, dentistry and accounting. Only crazies like us believe we can survive making our art and robots. Our mother was the rebel in her Kyoto family, which is why she left for America. She did not want to be constrained by centuries of rigid family traditions when launching her kimono business. She wanted total freedom. San Francisco was the only way that she could truly become herself, an innovative kimono designer doing what she wanted. Marrying dad, another rebel who ran off to Osaka to learn Bunraku puppetry, was the worst and best thing that she could have done. Their families virtually disowned them by cutting off their financial support and not celebrating their wins. My parents loved each other's craziness and joy so our home was always filled with love, laughter, kimonos and puppets. Ever since we were tiny tots, my parents drowned us in art, music, puppets and kimonos. We lived in our fantasy worlds with larger-than-life designers, musicians and puppeteers. We never knew that our classmates avoided the arts and were scolded for playing with us. Too bad for them, but it did make it lonely since people thought we were weird. Thankfully, Steve and Mayor Tiffany were crazies like us. Hardcore gamers, they babysat us by playing games and challenging us. Without them, we would have been latchkey kids.

"How does your mom want to show her kimonos in Bop City?" asks Steve, pulling it up in our Virtual Japantown site.

"She prefers a classic Heian look," I reply. "With princes riding horses."

"Easy. My team can add the horses. We just need the kimono patterns from your mom."

Yumi and I badger mom for her designs, which she reluctantly gives to us.

"I don't know why you always go online," she complains. "Real life is better."

"We need VR for marketing and selling your designs. Don't you want global fans?"

"I have them since I beat Mayor Tiffany in our showdown at city hall."

"That was last year. People forget so we need to refresh their memories."

"How can they forget? We got two billion viewers cheering for me. Even better than Gangnam Style."

"But they're a franchise. You were just a political protest."

"But women never forget women politicians who hurt other women, especially poor artists like me."

"You're right but we still need your new designs for Bop City."

"What's this Bop City nonsense? I'm a Heian kimono designer, not some J-Pop girl."

"Yumi and I are planning to show our Noh-Noh Girlz rock band wearing your kimonos."

"You'll cheapen my image! Don't do it!"

"Please! We'll make sure they look fabulous."

"Like a bunch of dancing puppets."

"No, like flowing swans. We'll make them beautiful."

"I'm not sure…"

"Please, mom. Just this once."

"OK, but please keep the Heian Look."

"We will – promise."

My sisters are delighted. Now we finally have mom's approval for Bop City, which will blow everyone away, but we have to make her kimonos look exquisite. No cheap-looking J-Pop outfits, only the royal Heian Look.

With care and a light touch, Yumi, Mari and Emi put their heads together to discuss how best to show mom's kimonos in Bop

City. Mari has the brilliant idea of putting kimono princesses on modern motorcycles, which zoom off, transforming into galloping horses on paths in Golden Gate Park, which becomes ancient Kyoto. The transformation is so beautiful and magical that we catch our breaths.

Mari invites her Goth rock band, which writes a Heian song featuring lyrics by her friend who studied ancient musical instruments in Japan: Shō (mouth-organ), Hichiriki (oboe) and Fue (flute) wind instruments, the Sō (Japanese harp, or Koto), and Biwa (lute) string instruments, Kakko and Taiko (drums), and Shōko (Bronze gong). The soft, mysterious sends chills up our spines as Heian women dance in their gorgeous kimonos. We are stunned into silence. Our mother starts crying quietly.

"My Kyoto," she says. "My home…"

"We love you mom," says Mari, hugging her tightly. "In all your craziness, we finally understand why you are crazy about the Heian past. It's beautiful and it's our past, our present and our future built onto the past. There is no space/time separation. They all exist together at once, like dad's spirit, which laughs and dances with us now and forever."

<div style="text-align:center">THE END</div>

ABOUT THE AUTHOR

Sheridan Tatsuno is a San Francisco writer and principal of Dreamscape Global, a writer, media producer, publisher, urban planner, business adviser, and serial entrepreneur who specializes in virtual reality (VR) for urban design, commerce and storytelling. He is advising Aimedis.com for personalized medicine and co-launching projects that provide VR solutions for designing, showcasing and building healthy cities. www.dreamscapeglobal.com

Trained in urban planning at Harvard's Graduate School of Design, Sheridan has worked as an urban planner in housing, public transit and major energy projects before shifting to high-tech market research and consulting at Dataquest in 1983. He is a fiction writer who began with short stories, novels, and poetry, then applied his storytelling to two business books produced for television: "The Technopolis Strategy" (Prentice Hall, 1986) about Japan's 26 science cities, which was produced as "Japan Dreaming" by Central Independent Television plc (1991) and aired throughout the Commonwealth; and "Created in Japan" (HarperCollins, 1990) about creative Japanese product design, which was used for the Kyoto scenes in the 4-hour PBS series "The Creative Spirit" (1992). He has written 18 screenplays and 15 novels.

His "Virtually San Francisco" sci-fi comedy series features 10 novels (available on Amazon) exploring VR for designing homeless shelters, entertainment, shopping, STEAM (STEM + Arts) education, space/time travel, and medicine. These novels were inspired by his work with a Swedish startup that used VR to design Copenhagen Malmo Port, Lund 2070, Malmo and Stockholm (2016-2020) with the Unreal 4.0 Engine. Aimedis uses Unreal 5.2 for its Healthy Cities platform. Demos at: www.dreamscapeglobal.com/blog/

His Linkedin articles about VR for sustainable cities, retail, STEAM education and medicine are available at:
https://www.linkedin.com/in/statsuno/detail/recent-activity/posts/
For details, contact: smtatsuno@gmail.com

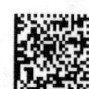

www.ingramcontent.com/pod-product-compliance
Lightning Source LLC
Chambersburg PA
CBHW072051230526
45479CB00010B/669